IMAGES
of America

WEST RIDGE

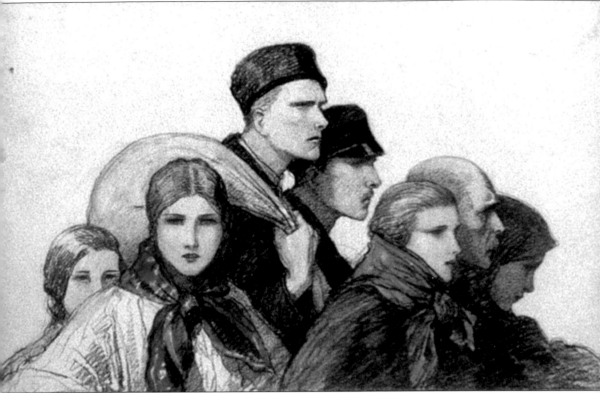

To invoke the phrase, "America is a nation of immigrants," is to call forth a complex image of the story of this great country. Scores of nationalities over spans of generations have come to this land amid great struggles and at tremendous risk to build a new nation. And while this book is a celebration of the immigrant communities in one particular piece of America—West Ridge in Chicago—it is impossible to tell that story without acknowledging the many brought against their will and a civilization all but wiped out to make way for a new America. (Library of Congress.)

On the cover: Pictured are Devon and Western Avenues in 1934. Perhaps more than any other corner in the neighborhood, this intersection represents West Ridge and the changes this community has seen over the years—from a Native American village, to an immigrant farming community, to a thriving Jewish shtetl, to a haven for new immigrants from South Asia and beyond—West Ridge's history is the story of the old and the new, change and stability, uniformity, and diversity. (Rogers Park/West Ridge Historical Society.)

IMAGES
of America

WEST RIDGE

Jacque E. Day and Jamie Wirsbinski Santoro

ARCADIA
PUBLISHING

Published by Arcadia Publishing
Charleston SC, Chicago IL, Portsmouth NH, San Francisco CA

Printed in the United States of America

Library of Congress Catalog Card Number: 2008923917

For all general information contact Arcadia Publishing at:
Telephone 843-853-2070
Fax 843-853-0044
E-mail sales@arcadiapublishing.com
For customer service and orders:
Toll-Free 1-888-313-2665

Visit us on the Internet at www.arcadiapublishing.com

This book is dedicated to Mary Jo (Behrendt) Doyle, founder and past executive director of the Rogers Park/West Ridge Historical Society. As one who viewed a complex world with childlike awe, she will endure in memory as she is here in her backyard on the west side of Ridge Boulevard with the world ahead of her. Doyle lived her entire life in West Ridge. (Rogers Park/West Ridge Historical Society.)

CONTENTS

ACKNOWLEDGMENTS

Mary Jo Doyle provided a strong, guiding, and affectionately stubborn hand through the process of our first book, Images of America: *Rogers Park*. No sooner than it hit the shelves, she turned to us with questioning eyes and said, "So now what about one on West Ridge?" Neither book would have been possible if not for her work over three decades, collecting and preserving north-side Chicago history and her hawklike protectiveness of the stories of West Ridge and Rogers Park.

We would like to thank the Rogers Park/West Ridge Historical Society's (RP/WR HS) board of directors for making the image collection available, and John Burns, Robert Case, Glenna Eaves, and the countless volunteers who bring West Ridge history to life through their diligent efforts.

Thank you to David A. Fortman, whose extensive knowledge and keen editorial eye challenged us to reach for a better, more accurate telling of our area's history.

Thank you to the following individuals whose histories and images capture the real story of West Ridge: Tom Borst, Maribeth Brewer, Tee Gallay, Jim Heckenbach, William and Dorothy Holland, Greg Johanson, Peggy Kelly, Martin Lewin Jr., Hank Morris, Sadruddin Noorani, Steve Saul, Nancy Seyfried, Martin J. Schmidt, Chuck Stepner, Karen Tipp, and John J. Zender Jr.

Thanks to Amanda J. Hanson and Pat Witry of the Skokie Heritage Museum, Irv Loundy of the Devon Bank, Julie Lynch of the Sulzer Library, Lori Osborne of the Evanston History Center, Lorraine Swanson of the *Chicago News-Star*, and Amie Zander of the West Ridge Chamber of Commerce for contributions to history and community.

Thanks to John Biel for help in dating many of the images that appear in this book and to Doug Brooks for his enduring support.

Thanks to Maribeth Brewer, David A. Fortman, Peggy Kelly, Martin Lewin Jr., Sadruddin Noorani, Robert A. Rodriguez, Chuck Stepner, Karen Tipp, and John J. Zender Jr. for making sure we got it right.

And thank you to John Pearson and Melissa Basilone of Arcadia Publishing for their patience and support in guiding this book from start to finish.

The authors may be contacted at westridgebook@gmail.com.

—Jacque E. Day and Jamie Wirsbinski Santoro

INTRODUCTION

The future has many names: For the weak, it means the unattainable.
For the fearful, it means the unknown. For the courageous, it means opportunity.

—Victor Hugo

To walk among the streets of Chicago's West Ridge neighborhood is to step through a meld of yesterday and today. The area is defined by a harmonic dissonance most personified by a disagreement over its name. Ask contemporary residents where they live and the answers vary— West Ridge, West Rogers Park, North Town. Each name reflects the rich tapestry of the past.

Before westward expansion brought Europeans to this area, it was home to America's first citizens—a variety of native peoples, including the Illinois and the Miami. Later, Potawatomi, accompanied by Chippewa (Ojibwe), and Ottawa (Odawa), camped along the high glacial Ridge.

In the summer of 1673, French explorer Louis Joliet and Jesuit Missionary Father Jacques Marquette, seeing what was to become the North Shore from the waters of Lake Michigan, called the whole swath of land Grosse Pointe (Great Point). The name stuck, and the area remained Grosse Pointe until the federal government negotiated the 1816 Treaty of St. Louis with the united tribes of Ottawa, Ojibwa, and Potawatomi and claimed a 20-mile tract of land 10 miles north and 10 miles south of the center of Chicago, Americanizing the name to Grosse Pointe Territory.

North Indian Boundary Line represented the northern of those lines, beginning at Lake Michigan in today's Rogers Park, slicing through West Ridge, and stretching diagonally southwest several hundred miles. Rogers Avenue is what remains of this symbolic line. Extending just a few city blocks, Rogers Avenue runs at a southwest angle and vanishes like a ghost, colliding rather clumsily with Touhy Avenue just a breath east of Ridge Boulevard. So while the city street on which North Indian Boundary was built does not reach West Ridge, Indian Boundary Park in the heart of West Ridge stands directly in its now-invisible path, a stark reminder of this history.

The 1833 Treaty of Chicago ceded all the remaining Native American land to the federal government and set the stage for the incorporation of the village of Chicago that same year. Settlers soon began flooding into the area.

It was on this wave that in traveled Irishman Philip McGregor Rogers, who arrived just as Chicago incorporated as a city. Rogers became one of the first deeded landowners in this area 10 miles north of the budding metropolis. Between the late 1830s and his death in 1856, Rogers

acquired approximately 1,600 acres both east and west of the ridge. This overlap became an impetus for the name confusion to come. When the community eventually split at the ridge, Rogers's name would continue to dominate both sides.

Rogers came to the great northwest from Watertown, New York, a point of origin for many early Chicago settlers. Lakeview founder Conrad Sulzer, and Martin Van Allen, organizer of the Ravenswood Land Company in 1868, moved from the Watertown area. And John Calhoun, who started Chicago's first newspaper the *Chicago Democrat* in November 1833, was also from Watertown. Rumor has it that the men often joked about renaming the area "Watertown West."

But the area's Prussian and Luxembourger settlers had a simpler name to describe their home—op der Retsch ("up on Ridge"). And so it goes that in 1850 Grosse Pointe Territory was renamed Ridgeville Township, with new boundaries extending north from Graceland (Irving Park Road) to Central Street in Evanston, and from Lake Michigan to Western Avenue. Life centered around St. Henry's Roman Catholic Church (built 1851), and five taverns. But the name Ridgeville did not last long. In 1857, it split into two sections: the northern section took the name Evanston Township and the southern section was organized as Lakeview Township. Within these smaller communities, more borders were to be drawn.

In the decade following the Great Chicago Fire of 1871, Rogers's son-in-law Patrick Leonard Touhy subdivided his late father-in-law's property east of the ridge and began to sell it off to in small plots. City folk—not farmers—began moving in. By 1878, Rogers Park became its own village, its western boundary ending at the ridge.

In 1890, fueled by disagreements with Rogers Park about taxes for local improvements, West Ridge incorporated as a village. Then just three years after gaining independence, West Ridge became part of Chicago on April 4, 1893. Rogers Park also joined the city on the same day and, for outsiders looking in, the distinction of where Rogers Park ends or West Ridge begins, slowly began to fade—both were part of the grand city of Chicago.

But for residents of both neighborhoods, Ridge Boulevard represents a border at once concrete and yet invisible. The north and west boundaries of West Ridge are bluntly clear—Howard Street and Evanston on the north, and the North Shore Channel and the Chicago city limits to the west.

But to this day, the south border of West Ridge remains opaque.

The city of Chicago sets the southern mark at Peterson Avenue from Ridge Boulevard to Western Avenue, dropping to Bryn Mawr Avenue from Western Avenue to the North Shore Channel. But while Peterson to Bryn Mawr is technically part of the community of West Ridge, the people living there are more apt to say they live in Peterson Park. Confused yet? It gets better.

In the early 1920s, as the area around Devon and Western Avenues began to develop, people began to refer to the area as the Devon-Western District. That did not stay long though, as the name North Town came into popularity just before the Great Depression, solidifying with the construction of the Nortown Theatre in 1931.

In 1947, the Chicago Park District acquired 13 acres on North Washtenaw Avenue for a new city park—they named it Rogers Park in honor of Philip Rogers. As a result, folks who lived near the area began to refer to their neighborhood as West Rogers Park.

By the 1970s, confusion about the name of the community became so commonplace that new immigrants from Pakistan, India, and Bangladesh simply referred to the area as Devon, a moniker known to people as far away as Karachi and Mumbai.

In recent years, the name West Ridge has made a resurgence. Some, eager to see the community step out of the shadow of Rogers Park, are pleased to revert back to the name of origin. Others feel a fondness for the names they grew up with—most often North Town or West Rogers Park.

What the name debate seems to imply is that an area this broad and diverse has more than one identity. Whether it is West Ridge, West Rogers Park, North Town or just "home," one thing is certain—West Ridge is a place made richer by virtue of the wonderful differences that lie within.

In Memoriam

Mary Jo (Behrendt) Doyle spent her early years playing in the empty lots and grasslands of Chicago's far north side. In the 1950s, as she watched asphalt, brick, and mortar replace the wild prairie of her youth, she filed the former into memory and moved optimistically into the future, celebrating the modern era, spending her hard-earned cash on Coca-Cola and teen magazines, and enjoying hotdogs and fries from Bill's near the northwest corner of Western Avenue and Howard Street.

Doyle viewed West Ridge and Rogers Park through the unique lens of past, present, and future. She brought that exceptional vision to her most beloved occupation, collecting and preserving the history of Chicago's far north side. Stubborn as she was, she was always willing to learn. After she cofounded the area's historical society, she discovered that her childhood home on the west side of Ridge Boulevard was really in West Ridge—not Rogers Park as she had always thought—a story she told often and with a youthful candor. In 1993, Doyle led the initiative to rename the Rogers Park Historical Society to the Rogers Park/West Ridge Historical Society.

Doyle passed away on December 17, 2007. The story of her life's work led the obituary page of the *Chicago Tribune*, second only to that of the nation's oldest veteran of World War I. Though she made it to age 68, most who knew her remembered her as childlike—viewing the world with admiration, amazement, and awe—and as an endless fount of stories. A trip to the Howard-Western Walgreen's with Doyle could lead to an hour-long recount of a stickball game on this very spot, played with her brother James "Chipper" and sister Dorothy Ann and other neighborhood kids at a time when the parking lot was just an empty patch of dirt and grass.

And to the very end, Doyle risked life and limb to procure a hotdog and fries from Bill's.

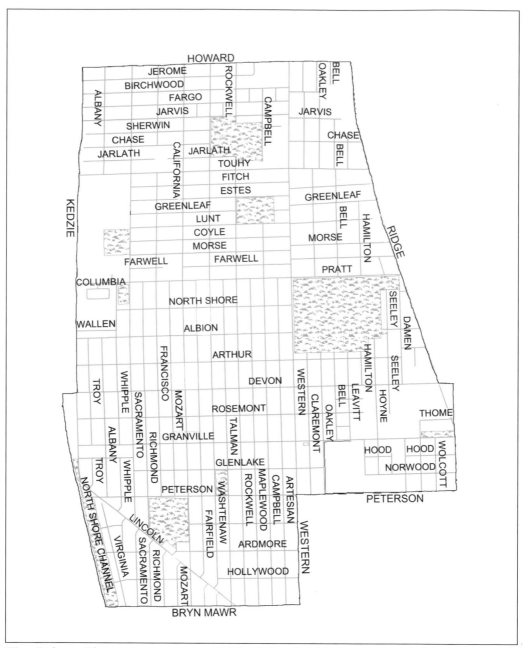

West Ridge is Chicago's community area No. 2. It is bordered on the north by Howard Street (Chicago's city limits) on the east by Ridge Boulevard, Ravenswood Avenue, and Western Avenue; on the south by Peterson and Bryn Mawr Avenues; and on the west by the North Shore Channel and Kedzie Avenue.

One

FROM WHERE THEY CAME

Let us not forget that cultivation of the earth is the most important labor of man. When tillage begins, other arts follow. The farmers, therefore, are the founders of civilization.

—Daniel Webster (1782–1852)

The first recorded history of the place now called West Ridge shows a sparsely populated area having a little woodland, meadow, and sloughs. An old Native American trail, known to Americans as the Green Bay Trail (today's Ridge Boulevard) served as a primary north-south passage through the area, and Native Americans who traversed the path formed close ties with French trappers and explorers. But the wave of an expanding, new America was fast approaching and with it came the hopes and aspirations of many who had heard stories of farm opportunities in the great Northwest.

The 1795 Treaty of Greenville, the "most momentous real estate transaction in the history of Chicago," captured the first federal lands in the Illinois territory—six square miles at the mouth of the Chicago River. Fort Dearborn rose in 1803 and fell with the War of 1812. The 1816 Treaty of St. Louis marked the first major seizure in Illinois history, a 20-mile-wide tract of land, 10 miles south and 10 miles north of Fort Dearborn, cutting through today's West Ridge near Indian Boundary Park. With the 1833 Treaty of Chicago, all Native American lands in Illinois were ceded to the federal government and the Chicago land grab began.

In Ireland, workers faced an epidemic of unemployment and poverty, with 75 percent of Irish laborers out of work in 1835. In Germany, with farmland at a shortage, young men were forced to work as laborers, and while wages remained constant, the cost of living escalated by 50 percent. Contrast that with descriptions of land and endless opportunity across the Atlantic Ocean. By the thousands, hopefuls boarded boats bound for America, often selling all their belongings to pay for the difficult voyage overseas.

As early as the reign of French King Louis VIX, the future West Ridge made for serious interest, as exemplified by the 1673 exploration of the area by Louis Joliet and Fr. Jacques Marquette. Called Grosse Pointe Territory by the legendary Frenchmen because of the promontory that jutted into Lake Michigan near today's Evanston lighthouse, the land of the ridge was occupied by vibrant Native American communities. (Library of Congress, LC-USZ62-116498.)

Once part of the powerful east coast Anishinabe nation but pushed west by America's expansion, Potawatomi occupied the ridge in the late 1700s. One Potawatomi village was located just south of Howard Street on Ridge Boulevard. From 1760 until about 1830, the Potawatomi found life on the ridge lucrative—to the west lay available hunting lands and to the east was access to great Lake Michigan. (Library of Congress, LC-USZ62-106105.)

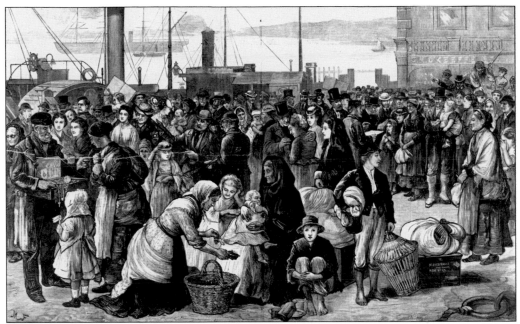

Young Philip McGregor Rogers, who emigrated with his parents from Queenstown, Ireland (above), and had grown up in Watertown, New York (below), set his sights on a wild, uncultivated land. Countless young Irish and German immigrants had already set out for the great Northwest, where land was cheap and in abundance and where opportunities were promised for young men of enterprising spirit. Encouraged by these stories, Rogers, who was not more than 20 years old, set out for Chicago with his brother, arriving sometime in the 1830s. While his brother continued on, Rogers opted to stay. A skilled prospector, he hedged his bets on a tract of swampland and prairie 10 miles north of the new city of Chicago, building his homestead on the highlands of an old glacial ridge. (Above, Library of Congress, LC-USZ62-105528; below, Jefferson County Historical Society.)

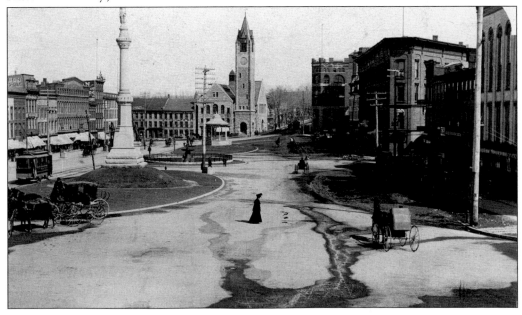

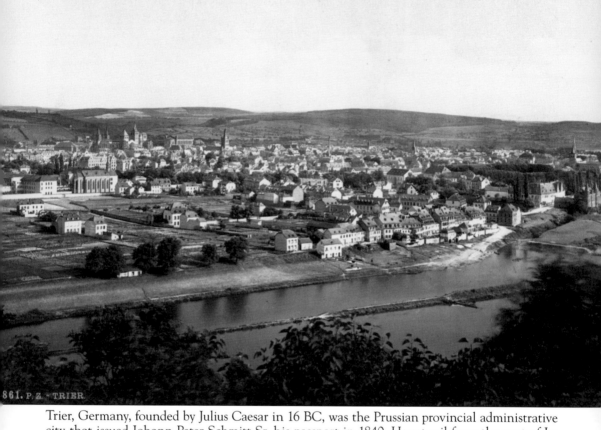

861. P.Z. - TRIER

Trier, Germany, founded by Julius Caesar in 16 BC, was the Prussian provincial administrative city that issued Johann Peter Schmitt Sr. his passport in 1840. He set sail from the port of Le Havre, France with his wife Maria, daughter Maria Anna, and twin sons Peter Jr. and Jacob. They had 6,000 French francs, amounting to $347,000 in today's money. Johann's mother was dead, as was his father, and three of his daughters were successfully married. If revolution in Germany was coming, surely America offered more opportunity. From 1840 through 1900, Germans formed the largest group of immigrants coming to the United States, outnumbering the Irish and the English. (Library of Congress.)

The 55-day transatlantic voyage aboard the U.S. clipper *France* was arduous, but the Schmitt family arrived safely in New York on July 27, 1840. Ships set sail between the months of May and October and typically traveled down the coast of Africa, across the warmer equatorial waters, and up the American East Coast to New York. (Library of Congress.)

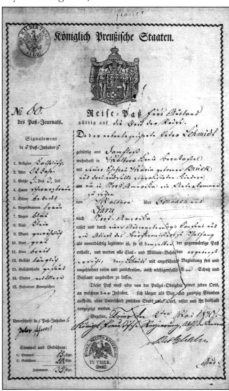

This passport, issued May 2, 1840, in Trier, Germany, shows 52-year-old Schmitt (here spelled Schmidt), his wife, Maria Bruck (age 48), twin sons Peter and Jacob (age 15) and daughter Maria Anna (age 21). What the passport does not say is that Maria Anna's sweetheart, 26-year-old Johann Zender, was listed on the ship's manifest as Johann Senter. (David A. Fortman collection.)

Johann Zender had a penchant for bucking authority. At the time of his journey to America, he faced years of conscripted military service in the Prussian army. Johann, like many young men of his day, stood at a crossroads. To remain in his home country would mean following the established conventions and toiling along in the old, accepted way of life. America stood for reinvention, a second chance, a new place to make a family with Maria Anna Schmitt. (Library of Congress, LC-USZ62-105846.)

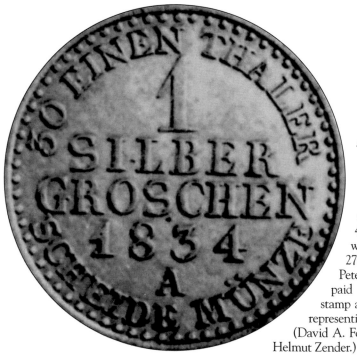

As they left Germany, Schmitt and Zender would have carried a pouch or tin box of *silbergroschen*, or silver pennies. At the time, a farm laborer earned 450 silbergroschen per year, while a simple farmhand earned 270 and a servant 90. Johann Peter Schmitt's passport shows he paid 15 silbergroschen for his tax stamp and 20 for passage permission, representing about four weeks of work. (David A. Fortman collection, courtesy of Helmut Zender.)

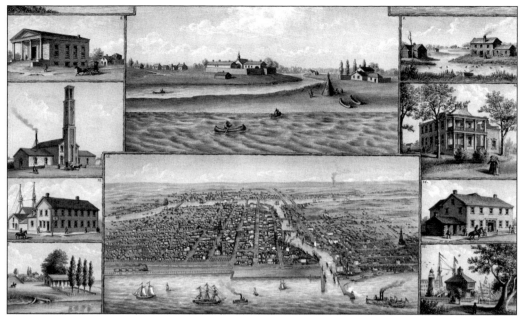

By 1840, the new city of Chicago had reached a population of 4,000 and was known by those who visited it as the filthiest city in America. Built on a prairie bog muddy from high water, in the spring, horses sunk into the street. Some made light of the situation, placing signs in the mud proclaiming "Fastest route to China." New immigrants, especially those interested in farming, purchased property north of the city where the land was higher and trees were sparse. Pictured here is one of the first cabins along the ridge. Built in the 1840s, it captures the pioneer experience that lay in wait for Philip McGregor Rogers, Johann Peter Schmitt, Zender, and others who followed. (Above, Library of Congress, LC-USZ62-56484; below, courtesy of Evanston Historical Society.)

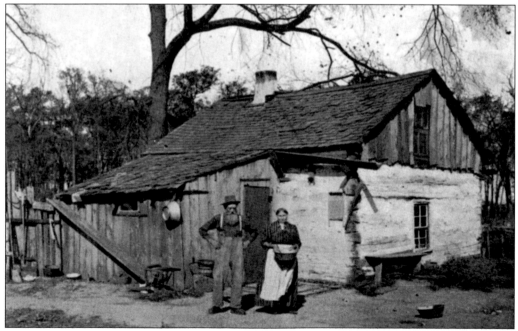

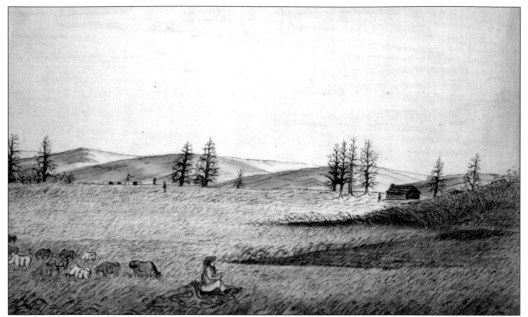

The settlers on the ridge spent the early years preparing the land and planting fruit trees to meet the growing needs of the city. The prairie land of the ridge was extremely attractive with few trees to cut and stumps to remove. But centuries of growing prairie grass and flowers had created a deep mat of roots, making the land extremely difficult to plow and break up. (Library of Congress.)

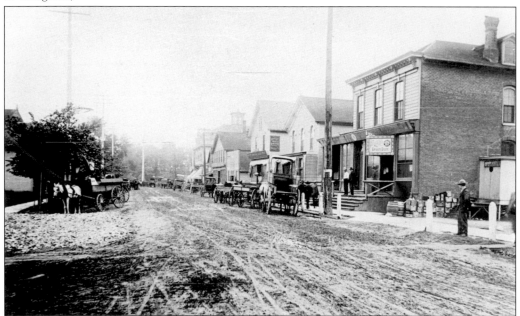

In the early years along the ridge, a trip to the post office involved a three-hour journey to downtown Chicago. When the U.S. Post Office opened a station at Dutchman's Point in Niles Center (today's Niles Center Road in Skokie), the trip was cut to an hour due west. By 1850, plank roads replaced dirt and allowed for easier travel to receive and send mail. (Courtesy of Skokie Historical Society.)

Two

LIFE ON THE RIDGE

The land up here looked like the home country.

—Joseph Winandy, 1928

The ridge played an incredibly important role in the lives of the new settlers. So when the Illinois legislature voted to allow Cook County to adopt township governments, it was no surprise when the people of Grosse Pointe renamed their community Ridgeville Township in 1850. A place of worship was the next order of business, and St. Henry's Roman Catholic Church went up in 1851.

As Northwestern University and the city of Evanston developed directly to the north and the city of Chicago to the south, the ridge became the destination for immigrants, particularly people from German-speaking nations. The next wave of newcomers to the area, Luxembourgers found the Roman Catholic community and familiar German culture a welcome attraction.

During those early years, St. Henry's and a handful of taverns along the ridge were anchors for the community. Still, living was hard—a cholera epidemic in 1854 took the lives of 3,500 residents of the Chicago area. Through the Civil War, the great Chicago Fire of 1871, and even a murder of one of their own in 1886, they toughed it out, forging a cohesive American community.

But in 1872, Philip McGregor Rogers's son-in-law Patrick Leonard Touhy subdivided the land east of the ridge near the present-day intersection of Lunt and Ridge Avenues, selling it off in small parcels to new residents. By 1878, enough people had accumulated on the east side of the ridge to form the village of Rogers Park. Soon the trendy metropolitan neighbors outnumbered the farmers of the ridge's western highlands 10 to 1. Offended that their tax money was being used to pave sidewalks and install streetlights in the increasingly urbanized village of Rogers Park and annoyed that their custom of drinking was being challenged by those in Rogers Park who wanted to go dry, the ridge folk, who played as hard as they worked, decided it was time for a change.

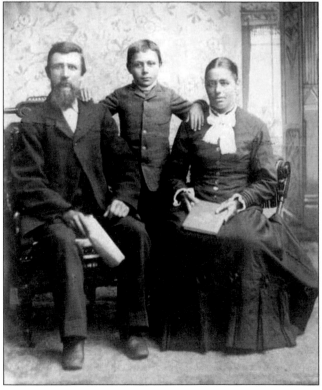

In 1845, the few family farms in Ridgeville Township belonged to mostly Prussian and Irish farmers. But significant political changes in Luxembourg (above), including overpopulation, high taxes, conscription into foreign armies, and dissatisfaction with foreign rule, brought a major influx of Luxembourg immigrants to the ridge beginning around 1855. These new immigrants were drawn to the area because of the established German community. Like the Prussians, they spoke German and shared many of the same values. Pictured at left are the Wietors, one of the first Luxembourger families to settle the area. Soon, names like Wietor, Wiltgen, Winandy, and Winkin became commonplace along the ridge. (Above, Library of Congress; left, Tom Borst collection.)

Old-timers and new-timers worked together to create the ridge community. Here is the first St. Henry's Roman Catholic Church, established in 1851 on the north side of today's Devon Avenue east of the ridge. Prior to St. Henry's, parishioners traveled four miles, rain or shine, to St. Joseph's in Wilmette or went as far south as St. Michael's on today's North Avenue. St. Henry's was Chicago's first German Roman Catholic parish. (Chicago History Museum.)

The American Civil War caused more casualties than just the fallen on the battlefield—orphan children. From that chapter in American history rose Angel Guardian Orphanage. Opened in 1865 near the ridge, the asylum was originally meant for orphans of German descent but came to welcome children of many backgrounds. Pictured here in the 1870s are the facility's power plant, bakery, and school. (RP/WR HS.)

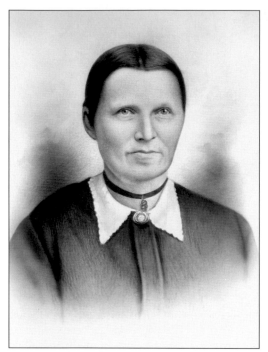

Some families, like the Schmitts, had now weathered more than 30 years along the ridge. They saw their share of pain, including the death of four of their young children during the cholera epidemic that brought the city of Chicago to its knees between 1855 and 1864. But they had also seen their share of success and were now able to reap the benefits of their hard work. In 1871, Peter Schmitt Smith Jr., who came to the ridge from Prussia at age 15, was now 45 years old, had married Elizabeth Phillip (pictured), and Americanized his name to Smith. He built this stunning home at 6836 Ridge Boulevard for a cost of $5,000. The home still stands and has been in the same family for 137 years. (David A. Fortman collection.)

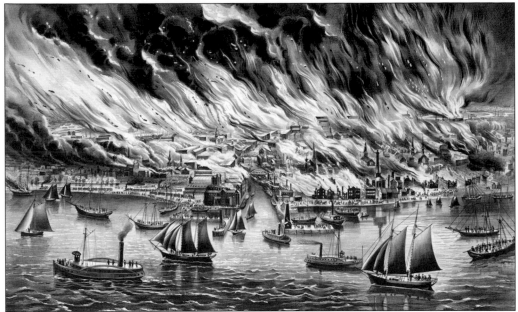

It was also in 1871 that a fire began at 137 DeKoven Street in Chicago, quickly spreading into a conflagration that ravaged the city for two days, destroying a four-mile area, including all of downtown. The Great Chicago Fire left thousands looking northward. West Ridge, far away from the stink and rubble, saw fire-prompted migrations well into the 20th century. (Library of Congress, LC-USZ62-14092.)

Perhaps the most disturbing event that occurred in Ridgeville during these years was the murder of Henry Muno. On Halloween eve in 1886 on his way home from church, he was attacked and murdered for pocket money. A missing local farmhand was blamed. Here is Muno's family in mourning. (John J. Zender Jr. collection.)

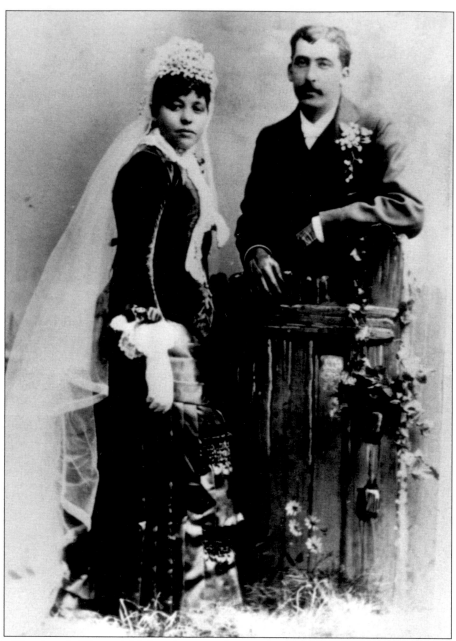

Family life, church life, social life—this was what was important to the 300 residents of West Ridge in 1891. Despite the challenges they faced or maybe because of them, this group of farmers and friends continued their path of community building. Traditionally impervious to distractions, there were two disputes they could not ignore: the huge growth in population in neighboring Rogers Park that used up resources and jeopardized the old way of life along the ridge and the demands by neighboring Evanston to stop the sale of liquor in their territory. It was time for a stand. Swayed to action by the disregard and ill treatment of the insular agrarian community west of the ridge, Adam Zender (pictured here with his wife, Helen Reinberg, at their 1881 wedding) joined a group of concerned citizens to take up the cause that incorporated the Village of West Ridge in 1890. (John J. Zender Jr. collection.)

Three

THREE YEARS A VILLAGE

*I do solemnly swear that I will support the Constitution of the United States
and the Constitution of the State of Illinois, and that I will faithfully discharge
the duties of the office of Trustee of the Village of West Ridge,
Cook County, Illinois, according to the best of my ability.*

—Adam Zender, 1891

Spirit built the ridge, and no doubt about it, the binding ties of this immigrant community revolved around two great spirits—God and liquor. It is a popular tale that West Ridge incorporated to fight back against sanctions that threatened to force their saloons to close. And while that is part of the story, it is much more complicated than that.

Residents of the ridge saw development all around them. Lake View Township voted for annexation to Chicago in 1889. The village of North Evanston merged with Evanston in 1874, and Rogers Park incorporated as a village in 1878. Living in an unincorporated township while those around grew bigger and stronger had some drawbacks. Families had only the most basic services and lacked the political parlor. Second, they lacked substantial political power to get anything done. In 1890, they decided to incorporate as a village to garner more services and gain political clout.

A petition was gathered to present to the court, and the ruling came down. If the majority of voters agreed to form a village, a village could be made. The court-appointed business owner J. P. Jaeger as the election judge. He posted notices at Trausch Brother's Grocery, Martin Jacque's saloon, Barbara Jaegers' dry goods and notion store, Dominich Didier's saloon, Peter Zender's saloon, and at the corner of Asbury Avenue and the Indian Boundary Line. The election was held on November 28, 1890, at Jaeger's store along the ridge. That day, 47 votes were cast, and the decision was unanimous. West Ridge would become a village. But another vote just three years later would change all that.

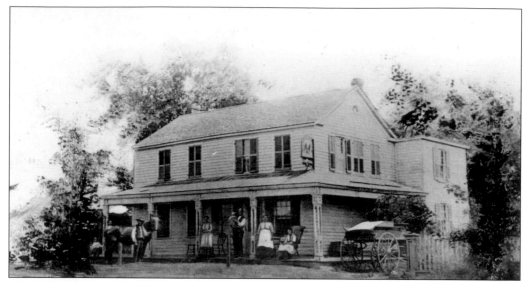

The Ridge Inn, pictured here, was built in 1836. Soon after, the Zender family took the reigns, keeping churchgoers warm with whiskey after a solemn service at neighboring St. Henry's Roman Catholic Church. This immigrant community was centered around farming, family, God, and taverns. But Rogers Park to the east and Evanston to the north were advocating for dry towns. The fight was on. (John J. Zender Jr. collection.)

"In order to make the sale of liquor legal," said Joseph Fitch, "the people had to organize for themselves." The liquor ban was one reason West Ridge incorporated as a village. These gentlemen enjoy what appears to be a stroll home after a night of high spirits. In the background, smoke pours from chimneys along the ridge, while St. Henry's Roman Catholic Church looms to the far right. (RP/WR HS.)

"Let us worry the patience out of their souls and the money out of their pockets until they prefer to follow any other business under heaven rather than the wretched and despicable one of liquor selling," wrote the *Evanston Index* on January 24, 1874, of West Ridge. "Failing to do this, our own sons may be bitten by the plague, and dragged down to worse than death." But liquor persecution was far from the little village's only concern. Improvements for its 400 residents— amenities taken for granted today such as paved roads and running water—were hard to come by due to lack of funds. Soon, talk of annexation was on everyone's tongues. Chicago was itching to absorb the little village and others like it in an effort to transform from a butcher's town into a first-class city. It was promising a host of new developments and services. For the struggling little village, the choice was tough—would they maintain their autonomy as they struggled along alone, or would they accept annexation in the hope of better days to come? (RP/WR HS.)

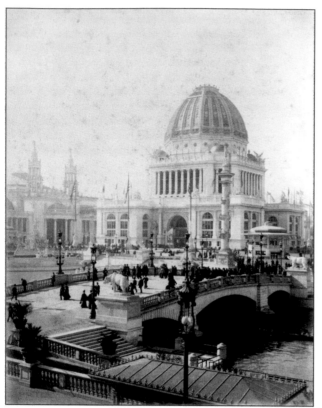

The year 1893 proved monumental for the little village that could. Joseph Fitch, in a 1928 interview, noted there was a "regular fever" for annexation. "People did it because the World's Fair was thought to bring prosperity to those within the city limits." On April 4, 1893, one month before the opening of the World's Columbian Exposition (left), West Ridge became part of the grand city of Chicago. Sibling and rival Rogers Park annexed the very same day. Overnight, Chicago expanded from 43 square miles to 168, adding 225,000 residents. With a population now exceeding one million, it became one of the largest cities in America. Though now part of the same city, metropolitan downtown Chicago and the dirt roads and open fields of West Ridge might as well have been on different planets. (Above, Library of Congress LC-USZ62-104794; below RP/WR HS, Lillian Campbell collection.)

Four

VILLAGE IN THE CITY

*There weren't so many people up here then but there were
enough to keep three or four saloons busy.*

—Mr. Malget, recalling the 1893 incorporation

West Ridge did not go quietly to the city of Chicago; it went with a bang. As John Muno recalls, "After we had turned over the books, we had a grand dinner . . . We had $1,600 in the treasury . . . we gave that money away in style."

But any thrill over being part of the city of Chicago was short-lived. Improvements came slowly, and taxation came swiftly. Some farmers went under. They watched with disappointment as eastern neighbor Rogers Park got the promised improvements first. Rogers Park seemed to have the advantages of public transportation, a commercial district, businesses, and shops.

West Ridge was green with fields of vegetables and rows of cabbages. These cabbage heads took on another kind of symbolism, when in 1896, Rogers Park sought to start the North Shore Park District to establish a series of parks along Lake Michigan. West Ridge countered with an application for its own permit for a Ridge Avenue Park District to build parks further inland. In a speech, future Illinois senator Jimmy Barbour suggested that the city assessors skip the West Ridge votes and count the cabbage heads instead, poking fun at the so-called backward nature of the farming community. West Ridge did not take this lying down.

With a cart—cabbage heads affixed to each of the four posts—West Ridgers paraded through the streets in what was called the Cabbage War. They also had another ace in their pocket. The middle-class Protestants and the few remaining Native Americans living in Rogers Park proper—but on the west side close to the ridge—sided with West Ridge in the vote. The Ridge Avenue Park District, formed in 1897 before Rogers Park was granted their permit, created four city parks: Morse (now Matanky), Indian Boundary, Chippewa, and Pottawattomie. Two of those parks are in present-day West Ridge, and two are on the west side of Rogers Park, pointing to a long-standing unity surrounding the ridge, whether on the east or west side.

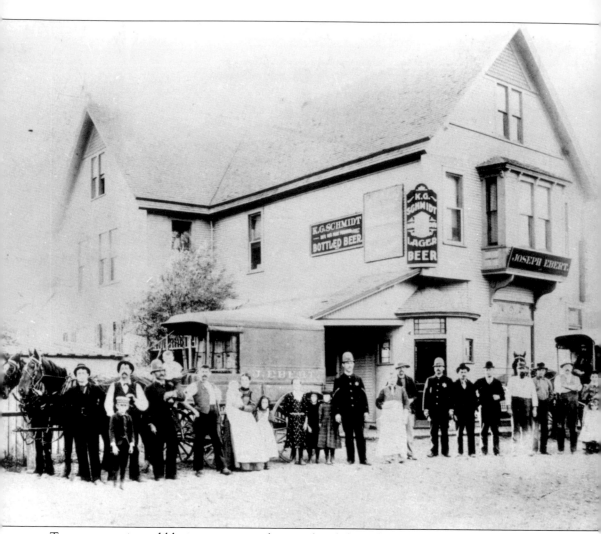

Taverns were incredibly important to the people of the ridge, and over the years, five inns sprung up. Each kept a healthy business serving parishioners, farmers seeking refreshment from a hard day's work, and folks looking for a bit of mischief. Ebert Inn was built in 1844 directly north of the Ridge Inn. Ebert's offered a generous free lunch with a 5¢ beer, card games, and a three-pin bowling alley. A brisk trade in beer and whisky kept delivery wagons busy as they strived to keep the thirsty patrons supplied. Nicholas Lulling, a Luxembourger farm boy in those days, remembers earning many bottles of free soda pop by washing bottles for the Eberts during rush periods. Beer was drawn from kegs into the bottles and then sold at 40¢ per case of 12 bottles. Whisky was also bottled in gallon containers at $2 each. (RP/WR HS.)

German immigrant brewers introduced cold brewed lager (or pilsner style) beer, which rapidly became the standard among immigrants and eventually among the general public. German beer barons like Schlitz, Pabst, Stroh, and Busch came to dominate the industry, adding innovations like refrigerated transport, bottling, advertising, and a sophisticated system of dealership and distribution. But in West Ridge drinking beer meant affordable fun and socializing with the neighbors. (Library of Congress.)

THE HOSTESS.

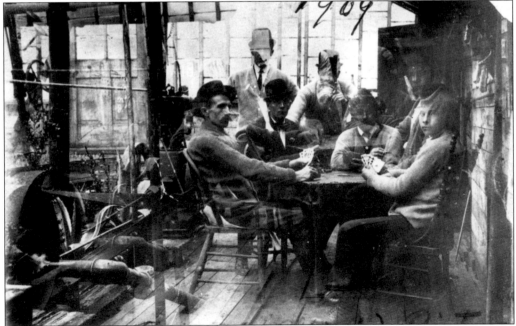

Cards were a popular form of entertainment for young men looking to save an honest buck for their piece of the American dream. Many found work in the farm fields and greenhouses of West Ridge. When it came to the end of the workday, these fellows found time for a card game. Sometimes an unfortunate soul lost a day's wages to an unlucky hand. (RP/WR HS.)

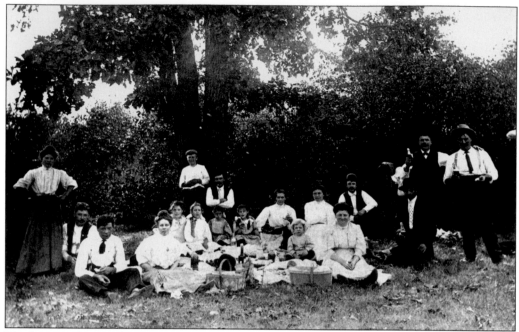

The beer gardens and picnic groves behind the inns were an inclusive gathering place where men, women, and children could enjoy each other's company. West Ridge women often gathered in these gardens to share stories and lunch with their friends. Hot food, drinks, and sandwiches were carried out to the picnickers. (RP/WR HS.)

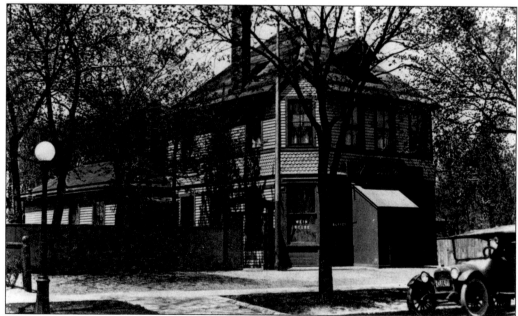

The Ridge Inn was renamed Karthauser Inn in 1908 when Nic Karthauser, a German-born immigrant, purchased it from the Zender family. A young boy in the early 20th Century, Albert Joseph "Bill" Fortman ran often to the inn for the customary bucket of beer for the greenhouse men's lunch meal. Bill's son David, during a conversation with his parents years later, learned "what really went on the second floor of the Inn in earlier times." (RP/WR HS.)

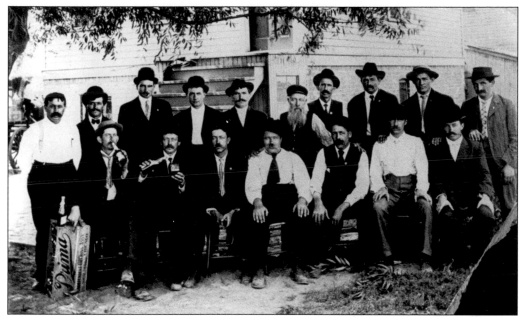

In 1886, Luxembourg immigrants had formed the Luxembourg Brüderbund or "brotherhood" with the goal of supporting each other in hard times. But they celebrated good times in equal measure. The biggest social event of the year came over the Labor Day weekend when Luxembourgers from throughout Chicago and as far north as Milwaukee gathered for the Schobermesse, a harvest festival celebration traditional in their native country. (RP/WR HS.)

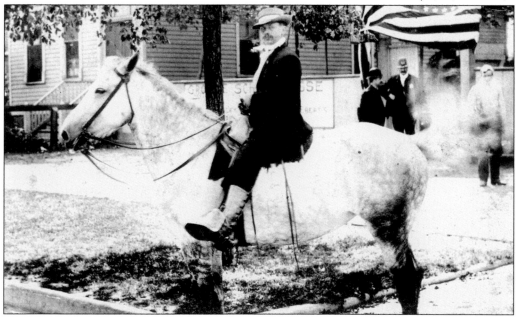

The first Schobermesse was held in 1904. The next year, a parade accompanied it. Perry Darbenfeld led the festivities on his white mare, and festivalgoers feasted on enormous quantities of hasenpfeffer, sauerbraten, sausages, and cabbage dishes. Tents were set up in the groves for displaying the best fruits, vegetables, and flowers, and men vied in contests and races and tried their skill at three-pin bowling on 60-foot-long sand alleys. (RP/WR HS.)

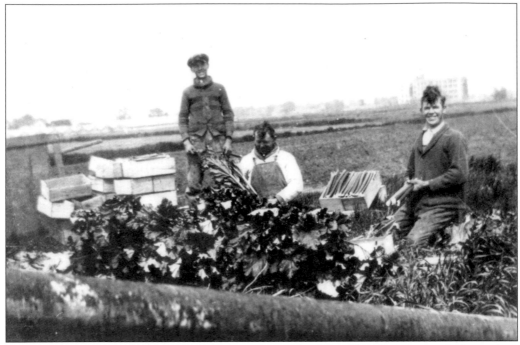

Here Frank, Gene, and John Wiltgen harvest vegetables from West Ridge's vast fields on their farm at Jarvis and California Avenues. In the background is the Chicago Fresh Air Hospital, a tuberculosis sanitarium. Most West Ridge residents were farmers who grew celery, beans, peas, melon, corn, cucumbers, and onions for the highly demanding downtown Chicago market. The daily trip downtown was not an easy one to make. It took three hours one way on rough and unforgiving roads. Farmers often left their homes at 2:00 a.m. to reach South Water Street to sell their goods. (RP/WR HS.)

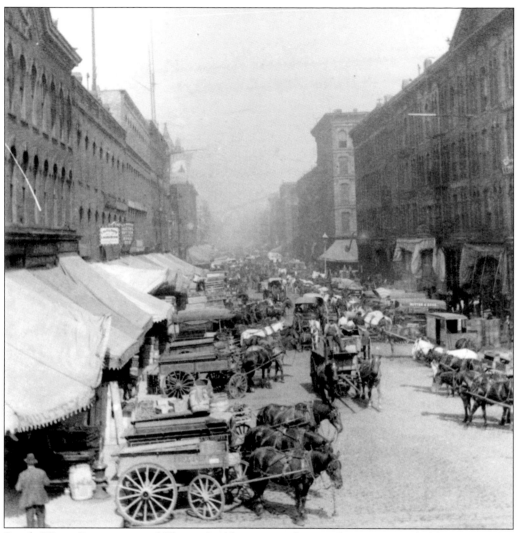

South Water Street is one of Chicago's oldest streets. It earned its name much like West Ridge did for its proximity to a dominant phenomenon of nature running along the south bank of the Chicago River. As the city grew, Water Street, with its proximity to both the river and the railroad, became the place where things happened. In 1848, the Chicago Board of Trade was founded at 101 South Water Street. By the dawn of the 20th century, the daily market had become a site to rival the New York Stock Exchange—a crowded gathering with frenzied buying and selling. Chicagoans and visitors alike found everything imaginable at South Water Street, but the congestion was unbearable. Daniel Burnham's 1909 "Plan of Chicago" proposed a solution that included transplanting the market from the heart of the business district to the west side. In 1925, the market moved, and Wacker Drive (upper and lower) eventually ran the route of the former South Water Street market. (Library of Congress, LC-USZ62-78621.)

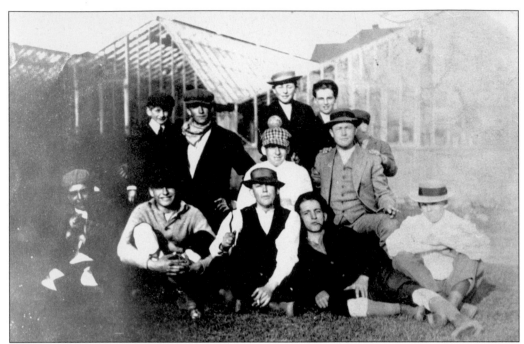

In 1882, John Muno and Adam Zender were the first to build greenhouses in West Ridge. They were inspired by the success of their friend Pete Reinberg of Lake View who had built his greenhouses a year earlier. Muno recalls, "We were friends of Pete Reinberg's and when he said, 'Boys, why don't you go into the greenhouse business,' we asked if he made anything on it. He said there was good money in it, so we started. At first we raised lettuce like Pete," recalled Muno. "Then he tried out roses and when he had made some money on them he said, 'Boys, you'd better get into flowers.' We said, 'Pete, is there any money in it?' He said he had made better money in flowers than in vegetables, so we went into it, too." (RP/WR HS.)

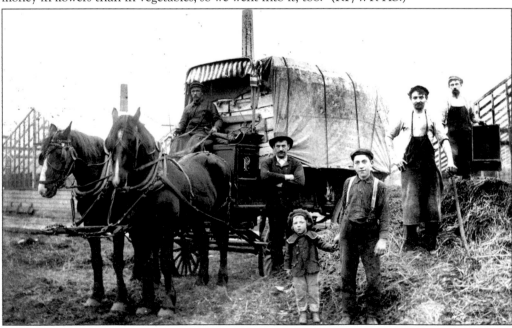

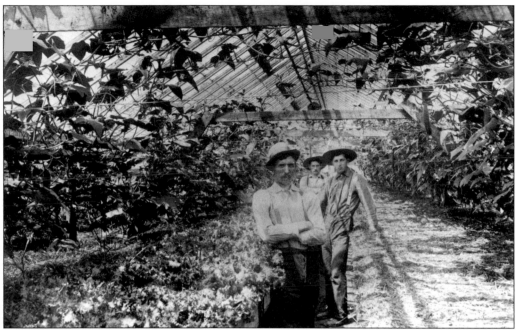

By 1900, greenhouses, called "hot houses" by some because they remained warm all winter, had sprung up on German and Luxembourger farms from Lakeview to Des Plaines and were a prevailing industry of the northern Chicago region. Growers provided cut flowers for the market, including roses, violets, carnations, orchids and chrysanthemums. Seen below is Nick Thinnes and his family on the porch of his home on Western Avenue just north of Lunt Avenue. The family greenhouses can be seen to the left. In 1908, another greenhouse was being constructed 10 miles to the south. The Garfield Park Conservatory, referred to by the *Chicago Tribune* as "by far the largest and finest floral conservatory in the world," was designed by famed landscape architect Jens Jensen and opened in 1908. (RP/WR HS.)

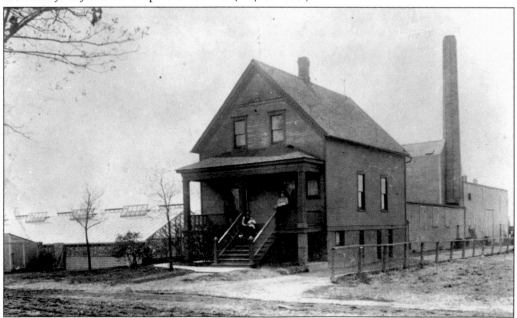

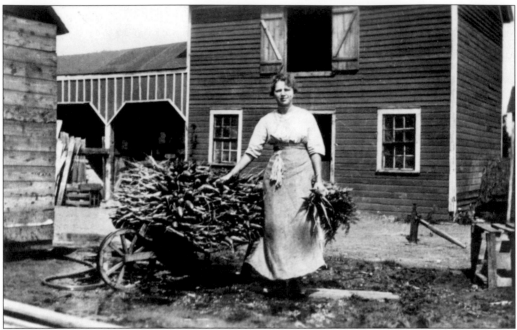

Farming was a lot of work, and women carried their share of it. Some, like Kate Wiltgen (above), played a key role in running their family farms. Many West Ridge farms—both outdoor and greenhouse farms—overwhelmed even the largest working families, and labor had to be hired out. Women came from outlying areas and from as far away as the south side to work as day laborers. "We used to send trucks down to Lincoln and Winnemac to get women to work for us," remembered John Muno. "Most of them were Polish women. We paid them $1.25 a day at first. Men were not so good as these women. They would take off their shoes and work on their hands and knees all day. They used to sing as they worked, too." (RP/WR HS.)

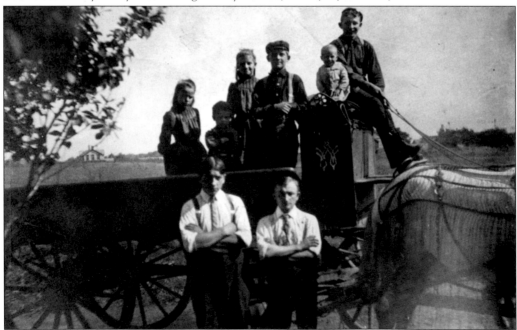

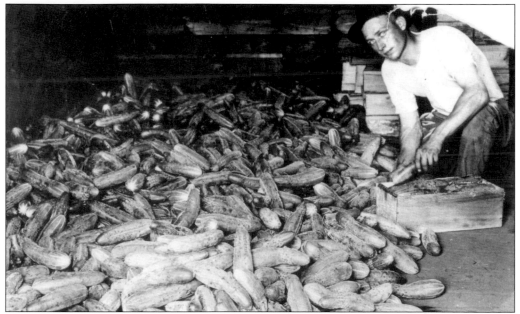

Cucumbers were one of the more popular crops for this area. Growers in West Ridge produced them by the truckload, and by the dawn of the 20th century, they were served up in posh downtown restaurants along with new radishes, sliced tomatoes, young onions, buttered beets, corn on the cob, mashed potatoes, pickled beets, cole slaw, and for dessert, rhubarb pie. (RP/WR HS.)

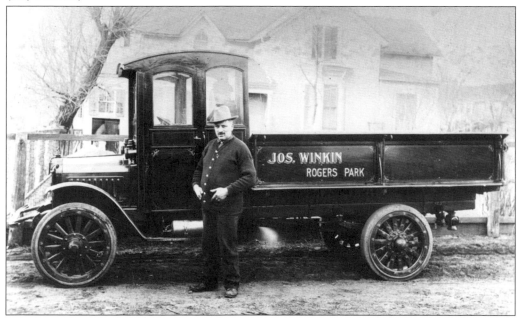

Joseph Winkin emigrated from Luxembourg in 1870, and made his living as a farmhand. By 1900, he had saved enough money to buy the old Muno farmhouse at 7504 Ridge Boulevard. "The only thing I can tell you about the annexation to Chicago is that some of us farmers did not want it. The taxes were higher the next year after we went in and it went so hard on some of the farmers that they were ruined completely." (RP/WR HS.)

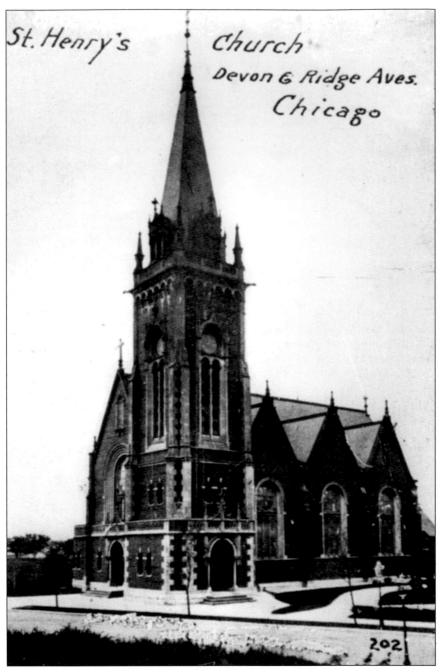

St. Henry's Church
Devon & Ridge Aves.
Chicago

When it was established in 1851, St. Henry's Roman Catholic Church met in a modest building and the membership was made up of mostly German parishioners. The church was named for St. Henry II (972–1024) who was both a German king and holy Roman emperor. His wife Cunigunde of Luxembourg was a seventh generation descendent of Charlemagne. Both Henry and Cunigunde were canonized. Henry is the patron saint of Bamberg, Germany. Cunigunde is the patroness of Luxembourg. The construction of this grand edifice on the southwest corner of Devon Avenue and Ridge Boulevard, just a little more than 50 years later in 1905, illustrates just how much the parish had grown. (RP/WR HS.)

Historically the Catholic church, including St. Henry's, served a much broader role than just a place to pray. Priests and nuns acted as community stewards, historians, educators, and caregivers. They were social servants before social service agencies existed. Here is Sister Claudia of the Evert family who was called to service at a young age. (Peggy Kelly collection.)

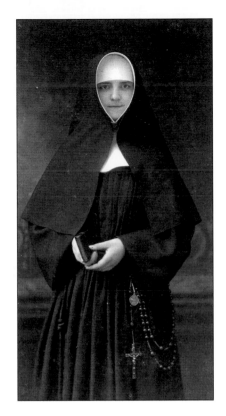

In this ornate ordination photograph of a St. Henry's priest, a young girl is dressed as the priest's bride. This reflects the teachings of the Catholic church with the priest representing Christ, the bridegroom, and the young girl representing the church, his bride. (Peggy Kelly collection.)

"St Henry's school at the Angel Guardian Orphanage was the only school nearby and all the children went there. Children came from miles around and some children from Niles Center attended school there," said Kate Lulling. When the school opened, German was still the primary language of West Ridge, and school was conducted in the mother tongue. Indeed, Chicago and the outlying areas bore such a strong German contingent that well into the 20th century, one-room schoolhouses taught half the day in German and half in English. When the progressive Idleharts, a West Ridge parish family, hired an English tutor for their children, other families began also sending their children to the tutor. Above is a 1910 class at St. Henry's Parish School. Below is the 1915 Feast of Corpus Christi parade along Devon Avenue. St. Henry's Roman Catholic Church and Cemetery can be seen at right. (RP/WR HS.)

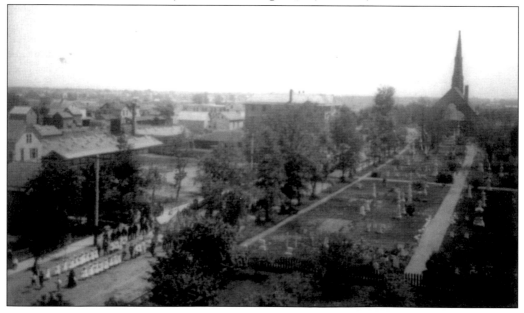

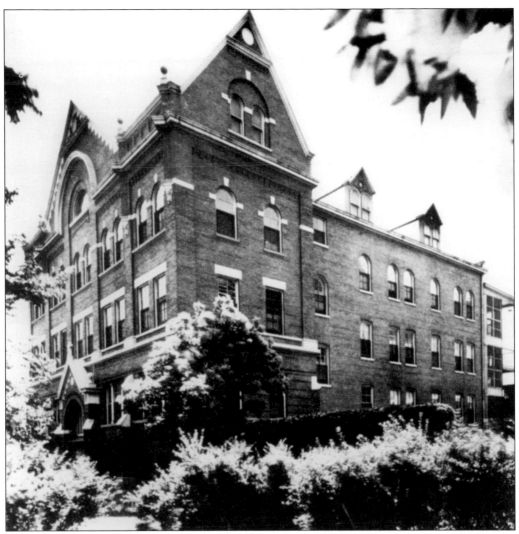

According to *A History of Angel Guardian Orphanage*, "In 1900 the population of Angel Guardian was 429 children. Six years later the number had grown to 584." Needy children continued to pour in, some having lost their families and others as referrals by the juvenile authorities. The orphanage got by on a little money provided by St. Boniface and by the generosity of parishioners. Still, overcrowding had become a big problem, and the orphanage had no money to build. A massive turnout to a June 1907 fund-raising bazaar held at the famous Coliseum at Wabash Avenue and Fifteenth Street brought in an incredible sum of $35,000 for the orphanage. The result was the Baby House (pictured). "In the building, called the Baby House, girls from two years to six occupied the first floor. Boys of the same ages were on the second floor. Their sleeping rooms stretched across the entire front of the building which faced the street. When the Devon Avenue street cars began to operate in 1917, this presented something of a problem during nap time." (RP/WR HS.)

It was at about the time of this 1914 photograph (above) that Angel Guardian Orphanage, to accommodate its growing numbers, adopted the cottage system. Sister Humbertina felt that for a great number of children to grow "physically, mentally, morally and socially," they could not be grouped together as they had been in the past. "How to make the individual child feel he was someone instead of a number lost in a crowd, how to let him know he is wanted, how to give him dignity of a person, these were the problems that went through the fertile mind of Sister Humbertina." The solution was to create cottages, or smaller home units for the children. The orphanage taught each child trades ranging from horticulture to sewing to the highly specialized craft of printing. Seen below is a 1913 girls sewing class. (Above, Chicago History Museum, ICHiDN-0062388; below, RP/WR HS.)

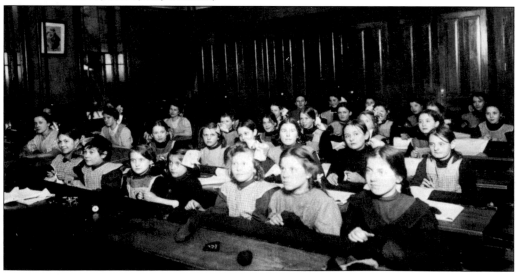

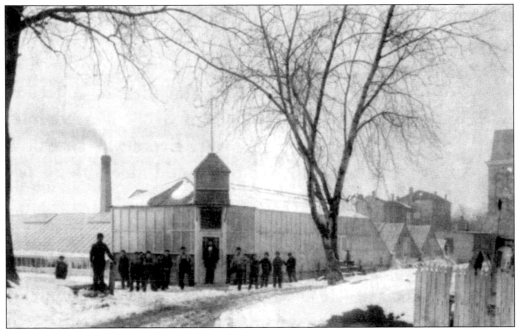

According to *A History of Angel Guardian Orphanage*, "For $3,000, Mr. Winandy was instructed to build the greenhouses south of the existing children's playground." The flower business was a principal industry of the area, and the success of the Winandy family in the building and operating of greenhouses was well noted by the sisters who ran the facility. Hence, the orphanage embarked on a venture—growing flowers—that became one of its signature legacies. "This small shop within the grounds became the center of a growing business for quite a few years." Lake View titan Peter Reinberg played an instrumental role in guiding the orphanage to greenhouse success. And in their time off from training for trades in gardening, Angel Guardian's boys continued to play baseball north of the greenhouses, knocking the occasional homer through the glass. (RP/WR HS.)

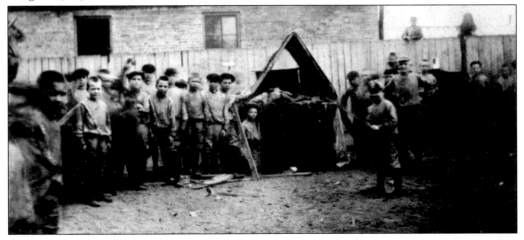

By 1910, though life had evolved, things were still pretty traditional in West Ridge, much as they had been when the first settlers arrived years before. Families still worked hard and played hard. Notice the boy with a pipe in his mouth. It was common for a child of his age to have completed formal schooling and be engaged in adult pursuits, including full-time work on a farm. (RP/WR HS.)

Before land speculators set their sights on the wide-open farmlands of West Ridge, children in this part of the city still had fresh air to breathe and open spaces to launch a horse into a full gallop if they wanted to. But the farms that survived the annexation were growing old and worn. The pastoral community of children pictured here changed dramatically by the time they reached adulthood. (RP/WR HS.)

Here a member of the Muno family enjoys the smell of the earth and a day's hard work. Although it is hard to tell by this photograph, the time of West Ridge's heyday as a farming community was coming to a close. The 20th century was here, and the expanding city took increasingly more notice of the wealth of land sweeping west of the ridge. (RP/WR HS.)

With modernization, Chicago slowly began to see the end of its last great prairie, and the area's first families like the Munos and the Zenders (seen here), after spending half a century along the ridge, were soon crowded out by developers, outsiders looking for a quieter life, and opportunistic businessmen willing to provide convenience for a cost. (John J. Zender collection.)

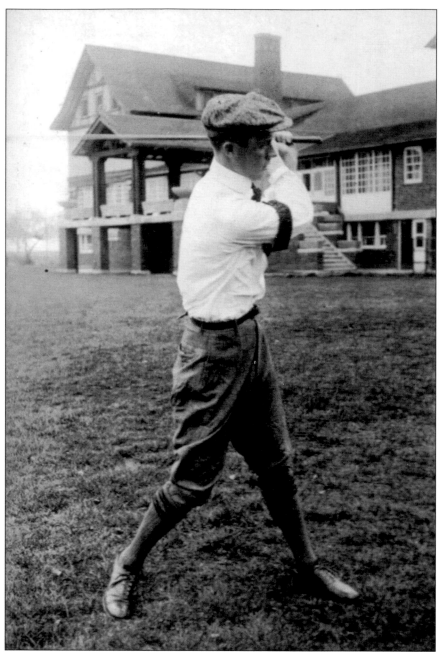

In 1913 following the death of his brother, Heinrich Fortmann sold the bulk of the West Ridge family farm to the Edgewater Golf Course, which was seeking to relocate inland from its then-lakefront location at Devon Avenue and Sheridan Road (in Rogers Park). When the 18-hole golf course moved to Pratt Avenue west of Ridge Boulevard, beautiful new homes rose up across the street. According to the *Chicago Daily Tribune*, "The procession of automobiles laden with caddie bags down Pratt Avenue has been continuous." The club was affectionately dubbed, "The Home of Chick Evans." Charles "Chick" Evans Jr. (pictured) worked as a caddie for the club in 1898 and later earned notoriety as one of the country's most popular golfers. (RP/WR HS.)

That same year (1913), Robert and Emily Hart sold their 40-acre tract at the northwest corner of Devon and Western Avenues to William L. Wallen, who divided the property into 128 interests, or shares, and made his plan to develop the property. A few years earlier, the construction of the North Shore Channel had drained the swampy land west of the ridge and this land, too, was ready for development. (Above, RP/WR HS, Lillian Campbell collection; below, RP/WR HS.)

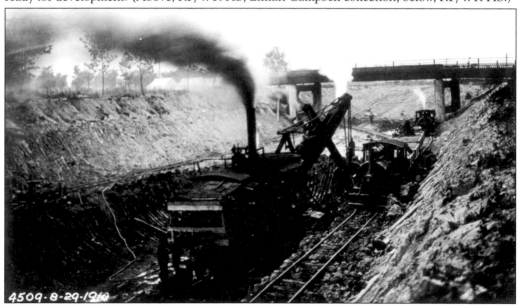

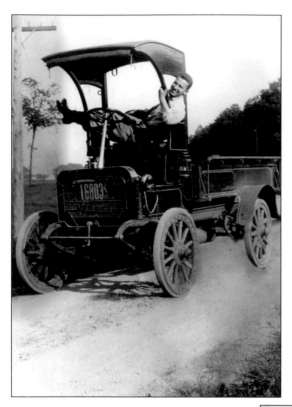

Here, 17-year-old Rudi Ulrich pauses for a playful pose on his high-wheels motorcar in 1912. The photograph was taken during the brass, or Edwardian era of the automobile, which lasted from 1905 through 1914. By 1914 the introduction of the assembly line enabled faster production and cars became accessible to the average consumer. (RP/WR HS.)

Dashing five-year-old Ted Ford hooks one arm around Marie Johnson (left) and the other around Adelaide Peterson on their first day of school in 1915. They are attending the still-new George Armstrong Elementary School, having opened just three years earlier in 1912 as the first public school in West Ridge. (RP/WR HS.)

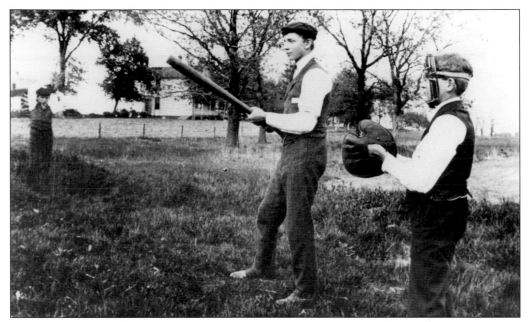

Farm work was hard, but West Ridge placed great value in its leisure time. Recreational activities, especially time with neighbors, family, and friends, was top priority. Here, boys take some time out after church to play baseball. Just entering its golden age at this time, baseball was fast becoming America's favorite sport. In Chicago, the Cubs began playing at Wrigley Field in 1916, and the White Sox, around since 1901, were World Champions in 1917. (RP/WR HS.)

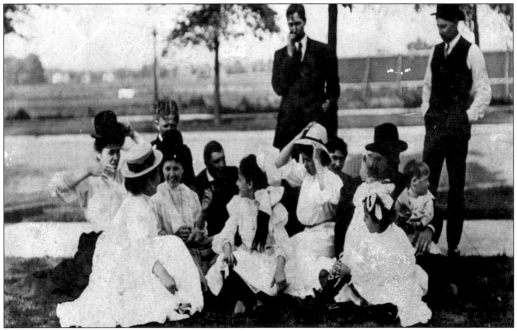

Grown-ups had their own fun. The worker's rights movements in the early 20th century saw a rise in weekend activities, and replacing images of people toiling from dawn to dusk were photographs like these of West Ridgers relaxing on the Sabbath. The somber Sunday vigil had no business here. It was time for good food and good times all around. (RP/WR HS.)

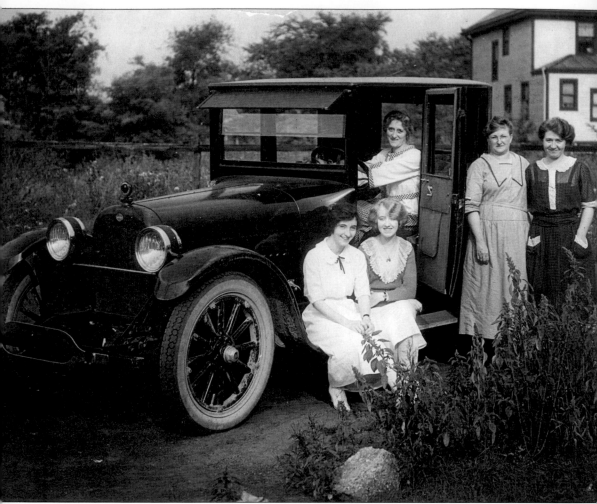

These were exciting days for women, as the campaign to secure a woman's right to vote moved into high gear. Before the decade's end, Congress ratified the 19th Amendment to the U.S. Constitution, and at this time, the suffrage movement had reached full steam. Women were gaining, demanding, and outright taking their independence. Skirts shortened. Hairstyles became more comfortable. In the second decade of the 20th century, women were geared up for an age of liberation. But with World War I casting a shadow overhead, this newfound freedom carried heavy responsibility. Decades before the fabled Rosie the Riveter era of World War II, American women stepped up to do their part in World War I, doing jobs they had never tried before, including delivering mail, working in factories, and driving ambulances. But these West Ridge women were no strangers to hard work—from the mature mothers who worked the farms with their bare hands to their daughters, they held their own. (RP/WR HS.)

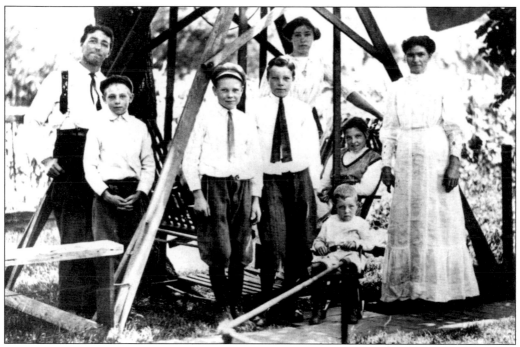

The neighborhood was slowly growing and the older, grand families of the ridge who made their money first in farming then, in truck gardening, then in flowers now had solid savings. With America heading into a strong wartime economy, there was more disposable income and greater decadence. There was also a surge in innovation as the country readied to equip its soldiers with state-of-the-art technology. Harley-Davidson was fast becoming the largest motorcycle manufacturer in the world, and as America's involvement in World War I became imminent, the military demanded motorcycles for combat purposes. (RP/WR HS.)

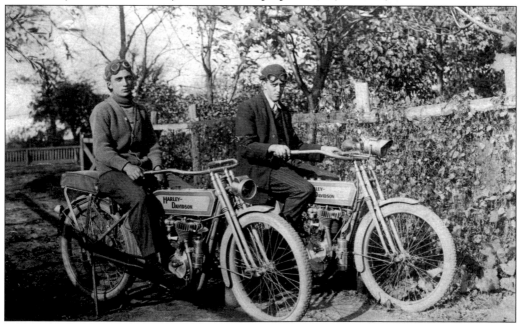

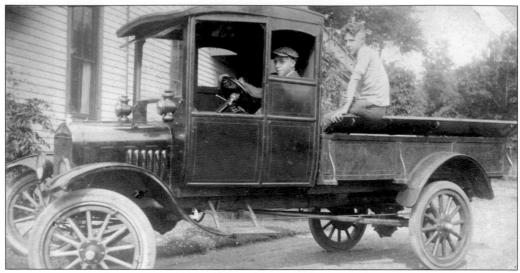

Although World War I began in 1914, the United States remained neutral and waited until 1917 to enter on the side of the Allies. Here, Edmund Fortman takes his brother Albert "Bill" Joseph for a leisurely ride in the family's truck. Many German Americans of "enemy ancestry" like the Fortmann's sought to distance themselves from their homeland. They gave up the speaking and teaching of German in neighborhood schools and concealed their fondness for German music. The Fortmanns dropped the second "n" on the end of their name to differentiate themselves from the Germans overseas. (Above, David A. Fortman collection; below RP/WR HS.)

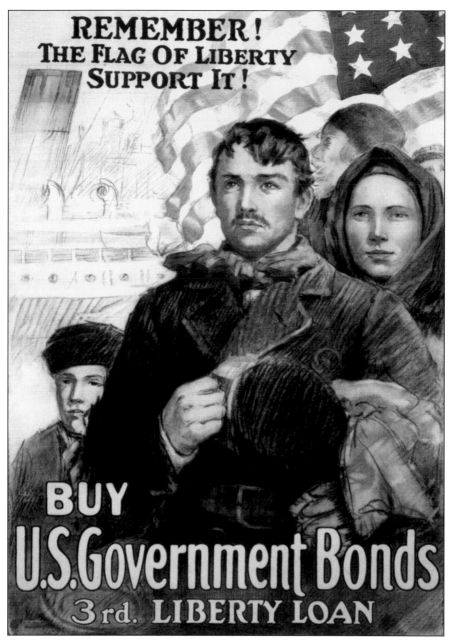

REMEMBER!
THE FLAG OF LIBERTY
SUPPORT IT!

BUY
U.S. Government Bonds
3rd. LIBERTY LOAN

In West Ridge, Germans and Luxembourgers fused into a homogenous culture. Peter Reinberg, for example, was German, while his wife was Luxembourger. "As far as I know the Germans and the Luxembourgers always got along together," said Joseph Fitch. But in regards to the war, they saw things differently. The Germans did not immediately galvanize for the brewing world war, partially due to Mayor Bill Thompson's assertion that any alliance with Britain would be traitorous. The Luxembourgers, on the other hand, were strong supporters of America's war efforts. Called by love of liberty and fear for their native land, they bought war bonds at a rate unprecedented by any other immigrant group. In 1917, the Luxembourg Brüderbund pledged support for the country's war effort against Germany in a memorandum addressed to Pres. Woodrow Wilson. (Library of Congress, LC-USZC4-9560.)

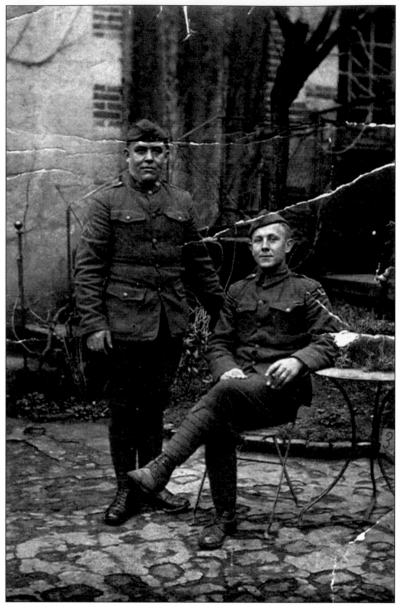

Jake Bierchen (standing) arrived in the United States from Luxembourg in 1906 and worked as a bartender in Ebert Inn at 6668 North Ridge Boulevard. At the onset of American involvement in World War I, just 11 years after his arrival, Bierchen received his draft card and went to war to defend his new country. New immigrants by the thousands were called upon to defend the United States, and they went eagerly, exhibiting extraordinary patriotism. American soldiers were given rousing send-offs with bands playing and crowds cheering and waving American flags. Although Bierchen returned home unscathed, three sons of West Ridge did not. Joseph J. Winandy, George Harles, and Peter Stephany lost their lives in the war. In their memory, this tight-knit community built a striking memorial in the courtyard at St. Henry's Roman Catholic Church. The inscription reads: "To the Prince of Peace In Gratitude to Our Young who Served Their Country's Cause in the Great World War, this Memorial is Erected by the Parishioners of St. Henry's Church." (Jim Heckenbach collection.)

Five

FAST TIMES, NEW ERA

This was never called West Rogers Park. It was West Ridge.

—John Muno, 1926

During the 1920s, the nation enjoyed the greatest burst of prosperity in its history, and West Ridge was no exception. Wages rose steadily and the idea of buying on credit became accepted practice. These changes allowed more and more people to purchase homes, and before long, bungalows and duplexes sprouted up throughout West Ridge, filling up the streets sometimes before the roads were completely cut and certainly before sidewalks were put in.

West Ridge did not grow all at once but rather much like patches of grass in the prairie from whence it came, in fits and starts. First the land from Ridge Boulevard to Western Avenue was filled in. Then for the first time, West Ridge expanded beyond Western Avenue to California Avenue. In little more than a decade, this area transformed from wild prairie to city, from dirt roads to paved, from horse and buggy to motorcar, and from pitch-dark nights to a land of streetlamps and the lights of a grand movie-house marquee.

This growth pattern resulted in multiple identities, or "neighborhoods within neighborhoods." The name North Town came into use for the commercial area around Devon and Western Avenues. Realtors hawked the name West Rogers Park to entice prospective buyers to the plethora of homes being constructed north of Devon Avenue, capitalizing on neighboring Rogers Park's popularity as the place to be for the well-to-do business class. One contemporary University of Chicago student wrote, "West Rogers Park has not as yet developed a common community consciousness; it is too new and too loosely bound together."

By the 1920s, West Ridge had entered the twilight days of its early immigrant roots. The once-thriving truck farms and greenhouses had already started to pass into obsolescence, and the days of family farms were decidedly over. But the land is charmed, and once again it called to newcomers. The population exploded from a mere 7,500 in 1920 to five times as many, over 40,000, by the end of the decade.

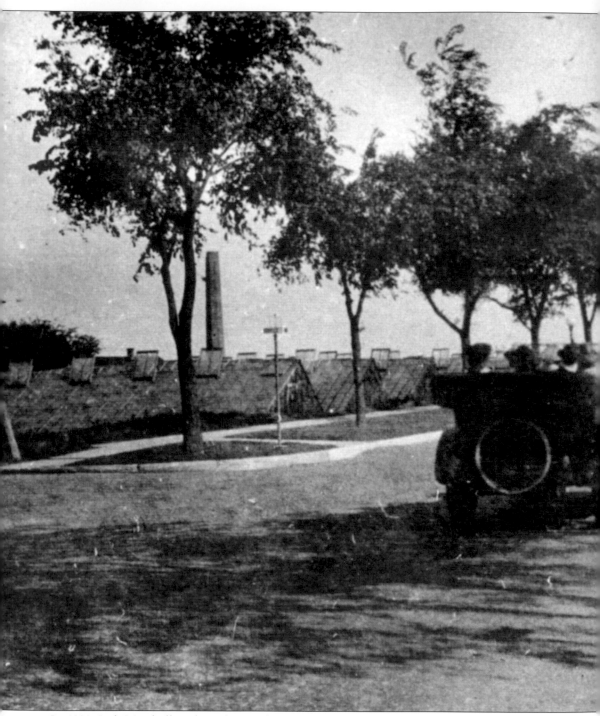

In 1928, Jack Marshall said, "When Ridge Boulevard was paved the bricks were brought from Galesburg, Illinois because they were better than the ones made here." In a stop-time image, these folks are out for a leisurely ride southward along the glacial ridge (now Ridge Boulevard) past Pratt Avenue (today's Pratt Boulevard). They go by greenhouses that in 10 years time will disappear. Eight blocks to the west lay a prairie where clay was mined and bricks were

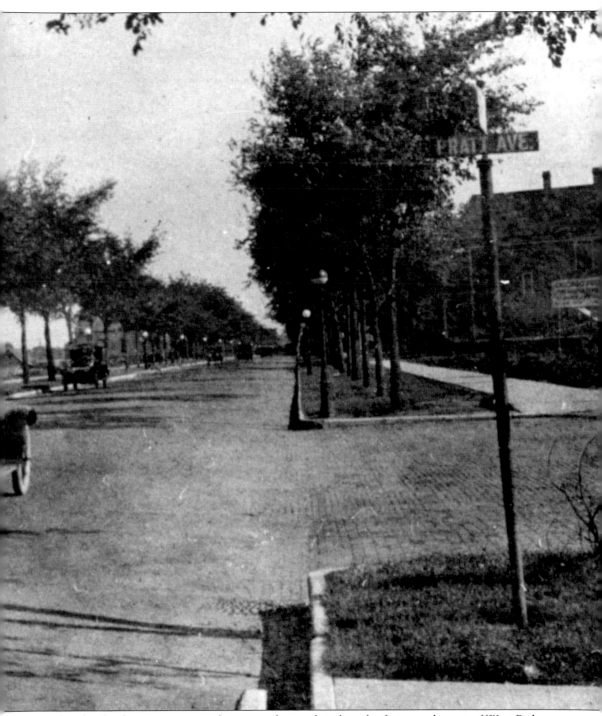

made—bricks that were apparently not good enough to line the first paved street of West Ridge. Despite this minor indiscretion, times were good. For the first time in West Ridge, people enjoyed the luxuries of wide, lighted streets, manicured lawns, and abundant trees. There was greater access to entertainment, literature, and art. (RP/WR HS.)

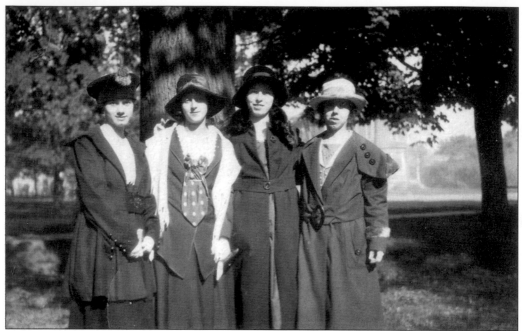

The 1920s were a time of liberation. With the 19th Amendment, American women could vote for the first time in the nation's history, and this new independence brought about an unprecedented push for the modern American female. While the older women still bore the tough no-nonsense sensibility of the previous generation the younger (above) sport bob-cut hair, wristwatches, and the fashions of the day. Boys also experienced new freedoms as families left the farms in record numbers during this decade and dads went to work in other fields, freeing young boys for the leisure of the day. Below, boys sport the floppy-uniformed look of Babe Ruth, the biggest celebrity of the 1920s, who transformed baseball from a minor barnstorming sport into the national pastime. (Above, Peggy Kelly collection; below, RP/WR HS.)

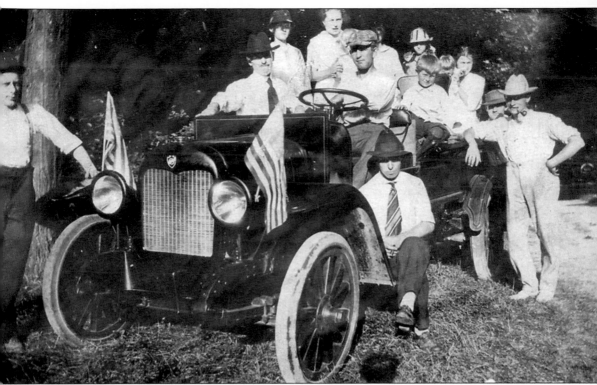

The ridge's first families, like the Schreibers, managed to move into the future while maintaining their Old World traditions: big families and love of country. Nicholas Schreiber, the patriarch of the family, emigrated from Germany in 1848. He purchased 40 acres of land near Devon Avenue and Ridge Boulevard, cleared the land, and began farming. Four years later, he died, leaving a wife and (a few months later) twin boys, Dominic and Michael. The boys attended old St. Henry's Parish School before taking control of the farm. For more than half a century, the Schreiber family engaged in truck farming and the florist business. In 1877, Dominic built a house at 6440 Ridge Avenue, where he lived the rest of his years. In 1935, at the age of 82, Dominic and Michael earned the distinction of being Chicago's oldest twins. St. Henry's Roman Catholic Cemetery sits on land donated by the Schreiber family. (RP/WR HS.)

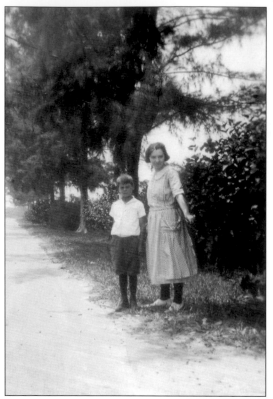

St. Henry's Roman Catholic Church and Angel Guardian Orphanage often eclipse the neighborhood folklore of the southeast tip of West Ridge. But just past the orphanage from Granville Avenue to Peterson Avenue, the Evert family quietly farmed the land from the mid-1800s well into the 20th century before it developed into a residential community. Their commodity, onions, earned a family elder the moniker "Onion Pete." Tennis professional Chris Evert hails from the West Ridge Everts. Pictured at left, Kate Evert stands with a boy, likely her brother, on the north side of Granville Avenue facing Ridge Boulevard sometime in the 1920s. Below, Mary Lynch and cousin Jerry Evert play in the yard of their grandparents, Pete and Katherine Evert. A fence separates them from the sprawling property of Angel Guardian Orphanage. (Peggy Kelly collection.)

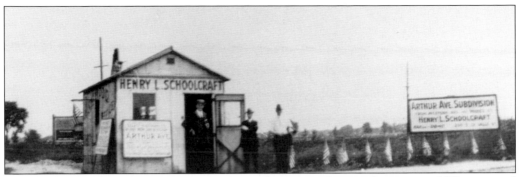

Henry Schoolcraft was one of many realtors who set up shop at the corner of Western and Devon Avenues and began to market the area both nationally and internationally to great success. In an effort to win business, Schoolcraft played up the character of the residents here to entice sales: "Each lot has been sold to people whom you will be glad to call your neighbors. Substantial, thrifty families who are in moderate circumstances. So you can rest assured that your neighbors will be of the best type of American citizens." The widening and paving of Western Avenue in the early 1920s bore a large influence on the rapid growth of the area. While around 1920 only 52 houses stood west of Western Avenue, by the mid-1920s that number had increased exponentially. (RP/WR HS.)

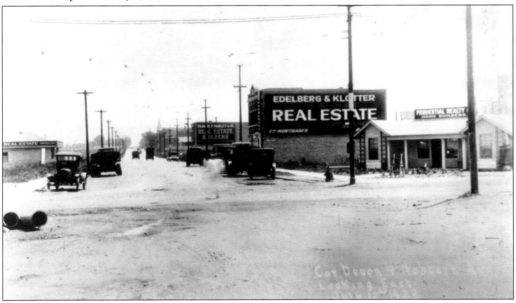

The northern section of West Ridge grew more slowly. Today, Howard Street and Western Avenue is one of the busiest intersections in West Ridge. This is what it looked like in the early 1920s. "There was very little west of us," said Azile Reynolds, first principal of Armstrong School. "Five years ago the streets were paved over west, but most of the houses have come in since 1925." (RP/WR HS, Lillian Campbell collection.)

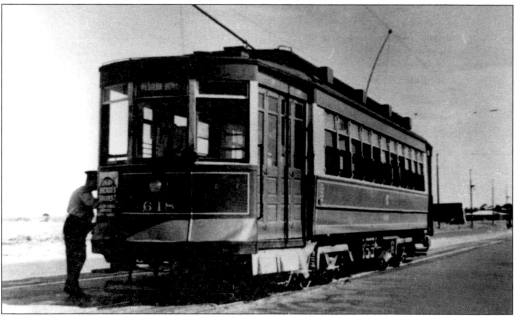

Here, the brand-new Western Avenue streetcar heads south from Howard Street. In 1925, according to a local newspaper, the *Lincolnite*, "A flag bedecked street car passed over the new tracks on Devon Avenue between Western Avenue and Kedzie . . . there were hundreds of people eagerly watching its progress." While the bus lines flourished, the famed Chicago "L," elevated train has never extended to West Ridge. (RP/WR HS.)

The white birch trees were ubiquitous sights of beauty in the early days of West Ridge. By the early part of the 20th century, the white birches fell victim to the rapid development of the area and the sale of individual home lots. Today virtually no trace remains of the birch forest that populated the area. Development was taking its toll on the natural beauty of the area. (Peggy Kelly collection.)

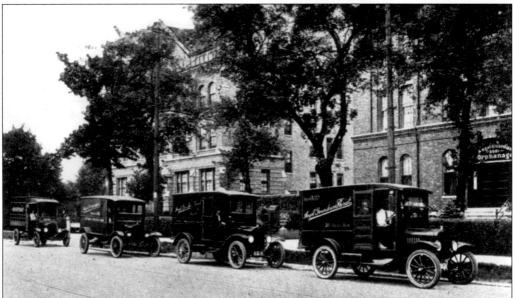

A few blocks to the north, another neighborhood institution approached an era-altering transition when George Cardinal Mundelein bestowed St. Henry's Roman Catholic Church, West Ridge's longest-standing religious institution, to Angel Guardian Orphanage. The parishioners of St. Henry's, who built the church with their dollars and hands, and had just finished paying off the mortgage, were livid. The great rift between the parish and cardinal lives on in neighborhood legend to the present day. (RP/WR HS.)

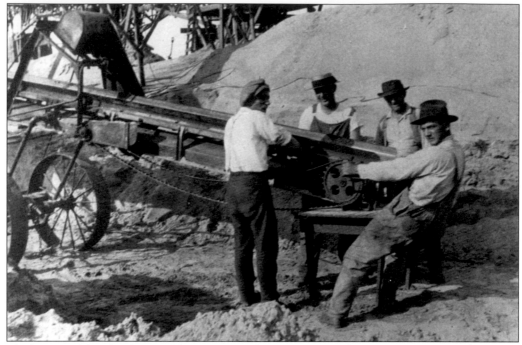

Blocks west of fast-developing Western Avenue, George, Joe, and Henry Phillips and John Muno work at Rogers Park Sand and Gravel Company along the North Shore Channel. In 1905, the National Brick Company purchased lands north of Touhy Avenue between Kedzie and California Avenues, and the rich clay pits of West Ridge supplied the raw materials for brick production essential to the building boom. By the late 1920s, constant mining produced a pit 90 feet deep, spanning an area equivalent to several city blocks. In the coming years, the clay pit was abandoned, and by the late 1940s, it had become a wildlife refuge and a playground. Many West Ridge residents recall sled riding in the pits as children, and birdwatchers made frequent stops to wonder at the dozens of species that called the pits home. (RP/WR HS.)

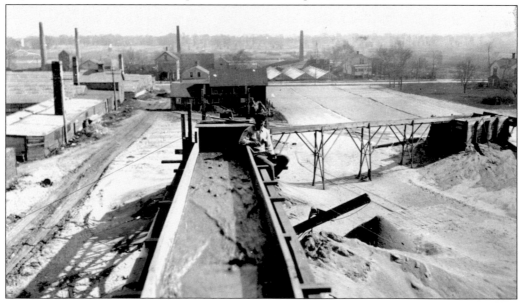

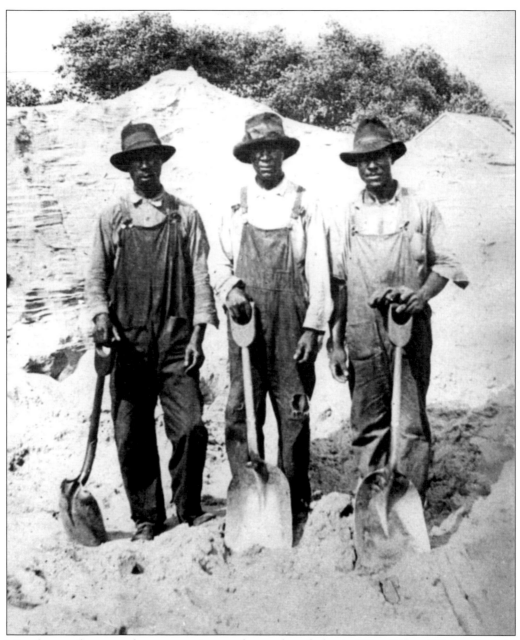

Men from miles around came to mine sand, gravel, and clay in West Ridge. "The workers in the yards are Hungarians, Scandinavians, Americans, and Negroes," said a 1920s document from the National Brick Company. Most of the workers made their homes in West Ridge with one exception. The black men arrived walking or via the Western Avenue car line. This period came at the helm of the great migration of 1917, when thousands of African Americans came to Chicago from the Deep South. But Chicago was still a very segregated city, and at the time, most of Chicago's black residents lived on the south side in the Bronzeville neighborhood. But not all African Americans coming up from the South migrated to the cities. Many opted for the outlying towns for the opportunities to own a home. At the time, neighboring Evanston had a growing African American community. (RP/WR HS.)

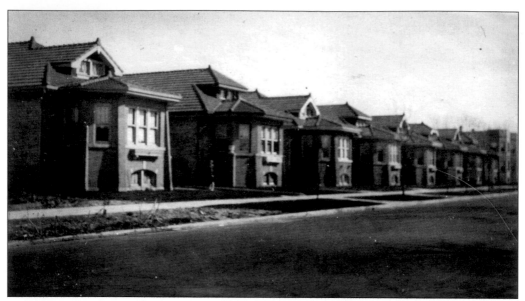

Overnight, the open spaces began to disappear. Brick bungalows and two-flats became the dominant residential structures in the neighborhood. Unlike Rogers Park, which had adequate public transportation and developed dense apartment buildings for housing, the construction was different in West Ridge due to the sparse transportation facilities in the area before 1920. Single-family dwellings were more common. The *Washington Post* called Chicago's north side a "Bungalow Belt." (Nancy Seyfried collection.)

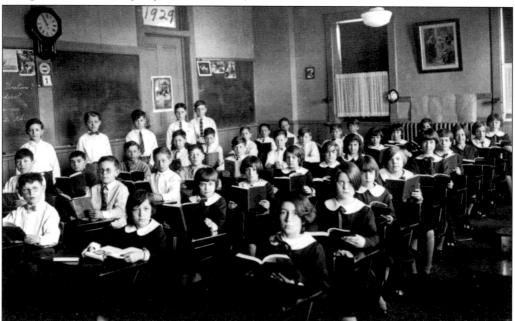

The fast-paced development and the burgeoning populace meant that schools were desperately needed, especially to accommodate the area's growing Protestant and Jewish populations, who did not typically choose Catholic schools like St. Henry's Parish School, pictured above in 1929. New public schools were built in this period, including Boone and Rogers, and businesses and places of worship to support the growing community were soon to follow. (RP/WR HS.)

It took decades for California Avenue to develop beyond farmland and prairie, but in the 1920s, a massive structure rose among the smattering of houses to stand as a prevailing anchor in memories for generations to come. Constructed in 1926 by the Peoples Gas, Light and Coke Company, the North Shore Holder dwarfed the greenhouses directly south and everything around it and was known commonly around the neighborhood as the "gas tank." "Any time we went out of town, I always knew we were home when I saw the gas tank," said Chuck Stepner, who grew up on the 6500 block of North Mozart Avenue. The gas tank remained a formidable presence, even serving as a marker for aircraft flying overhead until its razing. (RP/WR HS.)

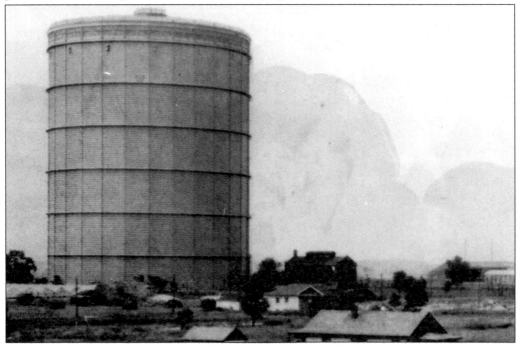

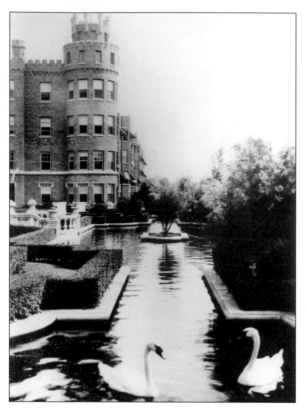

One of the most ambitious efforts of community architecture came about in the late 1920s with the construction of the Park Gables, Park Castle (left), Park Manor, and Park Crest. The four massive cooperative complexes surrounded Indian Boundary Park, site of the farm once owned by area founder Philip McGregor Rogers. The apartments were the height of class for their day, featuring beautiful landscape architecture, pools with swans, and a view of the park. Units sold rapidly for prices ranging from $6,000 to $12,000 each. "They are very splendid appearing apartments with a fine setting right on the edge of the park, as though that were their front yard," reported the *Lincolnite*. This 1930 photograph below features the park lagoon with Park Castle in the background. The buildings surround Indian Boundary Park to this day. (RP/WR HS.)

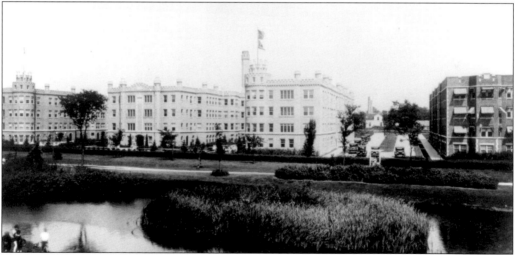

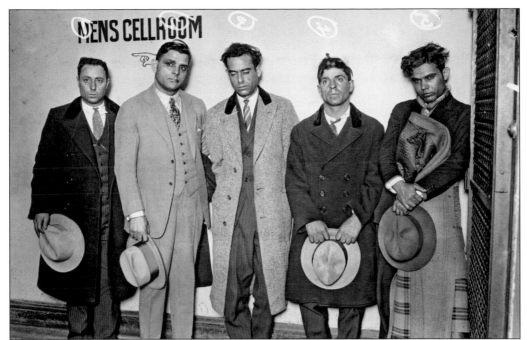

The 1920s gave celebrity-like prominence to the American mobster. Giuseppe "Joe" Aiello (second from left) was one such wiseguy. An ally of George "Bugs" Moran's north side outfit, Aiello lived in an opulent home on the 2500 block of West Lunt Avenue on the south side of Indian Boundary Park and often took in the beauty of the park. But Aiello's days were numbered. Al Capone's boys nailed him on October 23, 1930. (Chicago History Museum, ICHiDN-0084495C.)

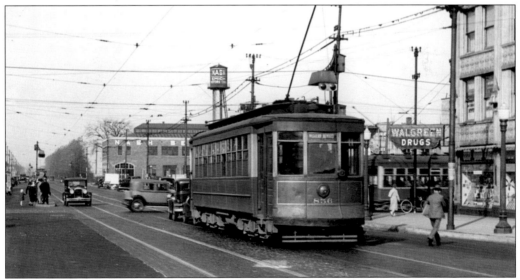

In 1910, Chicago's Earnest Sirrine patented the first automatic traffic signal, but it took decades to establish a uniform system. At the time of this 1920s photograph, cities were still figuring out traffic laws. Meanwhile, the intersection of Devon and Western Avenues was already shaping up to be an urban traffic phenomenon of automobiles, streetcars, bicycles, and pedestrians. It was on its way to becoming one of the area's busiest corners. (RP/WR HS.)

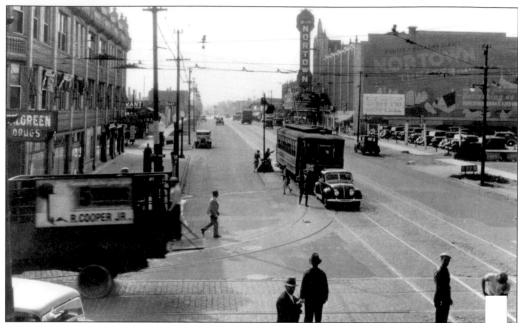

In a decade, West Ridge transformed from a sparsely populated farm community into a metropolitan center with many names, including West Rogers Park, West Ridge, and North Town. At the center was Devon Avenue, where shoppers could find anything, and people could take the streetcar to work or see a picture show at the brand-new 3,500-seat Nortown Theatre (above). A local newspaper of the day stated, "The B&K [Balaban and Katz] theater being erected at Devon and Western Avenues is to be called the Nortown, in deference to the wishes of the North Town Kiwanis Club, North Town Legion Post and other organizations which wish to preserve the name North Town in as many businesses and institutions as possible." In 1929, the term North Town, or "Nortown" as a neighborhood name came into use. (RP/WR HS.)

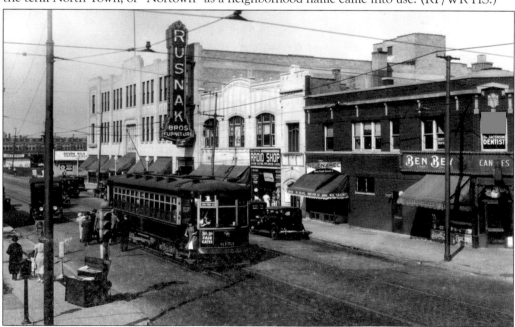

Six

THE GREATEST
GENERATION

Their time in West Ridge is reminiscent of a Horatio Alger saga.

—Martin Lewin Jr., of his parents, Martin Sr. and Ilsa Lewin, who escaped the Nazis

The close of the 1920s dealt a double blow to Chicago. At the Depression's onset, a citywide property tax strike had already crippled the local economy. By 1934, the crisis gripped not only the country but also the entire world. People stopped spending money as jobs shrank and savings were used for everyday living. In West Ridge, the population, which had increased explosively in the 1920s, leveled off at about 40,000 through the coming decade. And though the development that moved at a fever pitch in the decadent 1920s continued, it did so at a much slower pace. This lull carried on through the end of World War II.

For West Ridge, the carefree days of the Roaring Twenties were over. On the world stage, African American track star Jesse Owens put Hitler's theory of Aryan supremacy to shame, taking home the gold medal in the 1936 Olympic games in Berlin. Rogers Park's own Frederick Douglass "Fritz" Pollard Jr. was one of a few blacks to represent the United States at Berlin, earning a bronze in the high hurdles. But despite these victories, the African American struggle for equality was far from over, and Jews—openly forbidden by Hitler to represent Germany in the Olympics—were fighting for their very existence.

In Europe, a horror beyond the imagination was taking hold. With Hitler's National Socialist (Nazi) party on the rise, Jews with the opportunity to escape fled Germany, Poland, France, Italy, and Czechoslovakia. In America, the discrimination of Jews was not uncommon. West Ridge's Edgewater Golf Course (the future Warren Park) openly discriminated. Some residents even recall signs reading, "No Dogs. No Children. No Jews."

Amid these dark times, West Ridge residents remained steadfast, defeating economic crisis, learning to live as good neighbors, and striking hard blows at prejudice. During this period, American-born Jews and Jewish immigrants began migrating to West Ridge, planting the seeds for what would become one of America's most prominent Jewish communities.

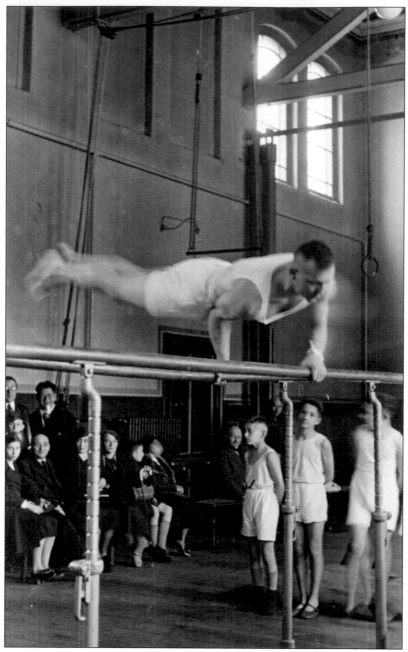

Martin Lewin Sr. may have knocked the world's socks off at the Olympics, but one will never know. An athlete who excelled in many sports, he achieved the distinction of Jewish amateur boxing champion of Germany and was a member of the handball team that qualified for the 1936 Olympics at Berlin. But because German law forbade Jews from participating in the Olympic games, authorities removed him from the team. Overcoming customs and paperwork nightmares, he and his sweetheart, Ilsa, escaped Germany to move to Chicago. They married in 1939 and lived in Rogers Park before building a small house on the 2800 block of Fitch Avenue in West Ridge. He then went on to become president of Jim Beam. Here he performs on the parallel bars in 1934 in Germany. (Martin Lewin Jr. collection.)

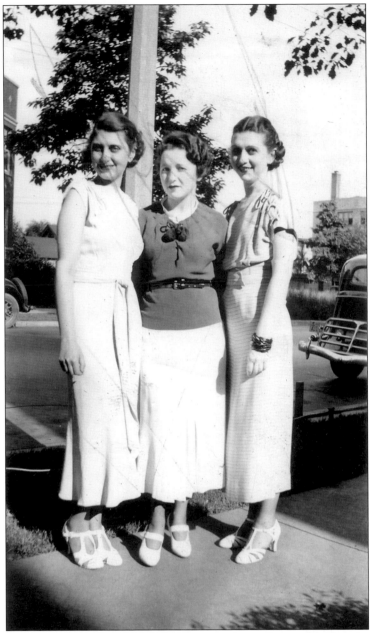

The 1930s marked the beginning of a Jewish migration to the neighborhood not only from Europe but also from other parts of Chicago. Seeking a quieter life and a community where they could feel at home, Jews began moving en masse to West Ridge. Florence Stepner (left), pictured with sisters Lillian (center) and Mildred, grew up in Chicago's Albany Park neighborhood. Shortly after her marriage, she lived with her new husband in Rogers Park, and in the late 1930s, they moved to the 6500 block of North Mozart Avenue, where she raised a family, walked to work every day, and was one of the founding congregants of Temple Menorah, built in 1948. After her death, recognition of Stepner's quiet efforts to teach children and new immigrants to read led to a city ordinance declaring a one-block section of Mozart Avenue as Florence Stepner Way. (Chuck Stepner collection.)

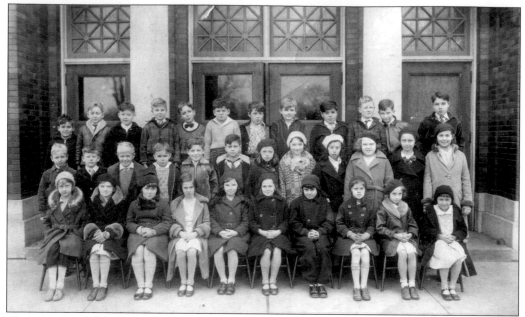

The schools of West Ridge had long been an incentive for families looking to relocate, but public education was one of many things to suffer during the Depression. Here is the 1933–1934 class of George Armstrong Elementary School in West Ridge. The school (opened in 1912) remained fully functioning despite a citywide financial crisis that left teachers without pay for months on end. (RP/WR HS.)

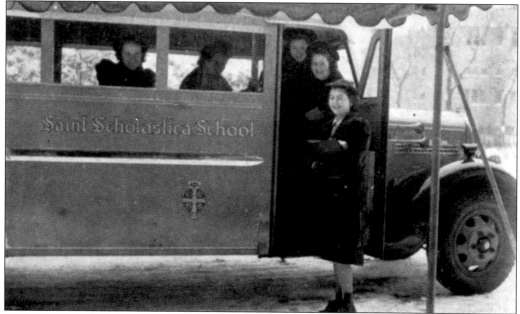

St. Scholastica Academy (shown in 1939), one of Chicago's oldest Catholic schools, opened in 1865 as a "finishing school for young ladies" in downtown Chicago. In 1906, to expand and accommodate the academy's patrons, it relocated to West Ridge, choosing "the only eminence available in the 'City of the Plains,' namely, the Ridge, or old shoreline of Lake Michigan." The academy remains today among West Ridge's most prominent institutions. (RP/WR HS.)

Certainly aspirations were affected by the economic challenges of the day, but the children of West Ridge, like Gertrude Payne and her brother, maintained a healthy fantasy life fueled by dreams of a better, adventure-filled future. Young boys read the pulps, mass-produced books named for the cheap paper on which they were printed, featuring characters like the Shadow, Doc Savage, Buck Rogers, Doctor Death, Nick Carter, the Phantom Detective, the Eel, and the unforgettable Zorro. Children crowded around the radio for the heroics of the Lone Ranger, the Green Hornet, and Jack Armstrong, all-American boy. Young girls closely followed the movements of Amelia Earhart and Eleanor Roosevelt. This was the era of Snow White and the Seven Dwarves, Shirley Temple, and Monopoly. In 10 years time, boys like these were flying fighters and bombers and storming the beaches of countries they had never seen before. These children, in their bows and tights and Gatsby caps, mark the dawn of the greatest generation. (RP/WR HS.)

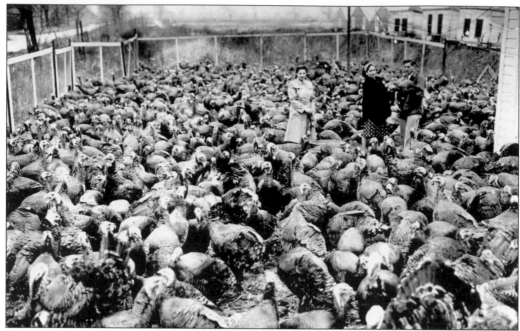

In the early days of West Ridge, wild turkeys had the run of the prairie, and in the 19th century, turkey became the Christmas dinner of choice for Americans. In a move to boost the economy, Pres. Franklin Delano Roosevelt made a proposal to Congress to move the Thanksgiving holiday to an earlier date to encourage a longer shopping season. Congress shot the idea down before it took wing. Depression-era turkey farming proved surprisingly lucrative in an otherwise depressed farming market. Pictured is Schaul's Poultry Farm, called the "turkey farm" in neighborhood vernacular, on the northwest corner of Pratt and California Avenues in 1939. To the present day, the people of West Ridge who are old enough remember the turkey farm. Dorothy Holland, who lived diagonally across the street, recalled, "Day and night, those turkeys went on." (RP/WR HS.)

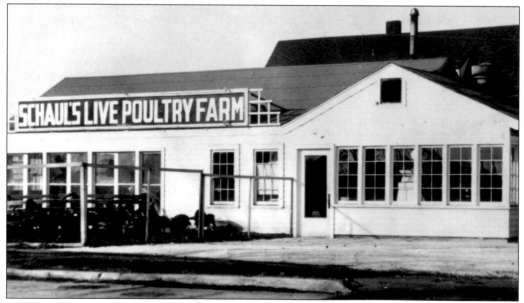

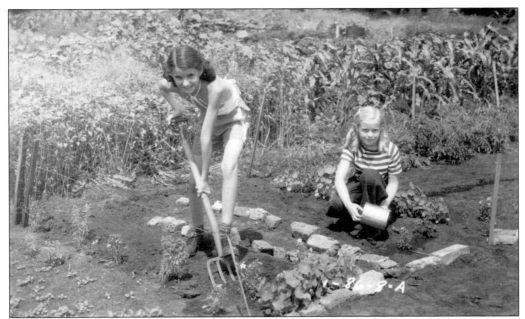

The residents of West Ridge struggled for everything. Jobs were scarce and the traditional backyard garden that grandma had tenderly cultivated for generations took on new importance in these times. The Depression fostered a new togetherness as people worked together at their business, school, and church. In this 1938 photograph, the children plant and harvest vegetables in Indian Boundary Park. (RP/WR HS.)

While the Depression impacted business and wages, namely those that had thrived under the 1920s building boom, it also put a premium on economically efficient activities that fostered new job growth. The greenhouses that flourished at the dawn of the 20th century gave way to railroads, which delivered flowers at cheaper cost. New industries sprang up, wholesale markets were created, and food store chains came to be. (RP/WR HS.)

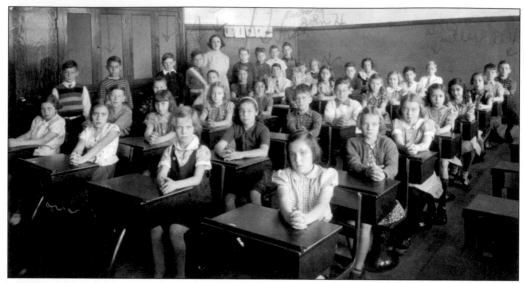

While public schools are taken for granted today, they had to be built one by one. In 1937, Philip Rogers Elementary School opened in West Ridge in an 11-room schoolhouse in the yet-to-be-developed area on Washtenaw Avenue between Touhy Avenue and Howard Street. In West Ridge's public schools, Jews, Protestants, and Catholics learned and played together. (RP/WR HS.)

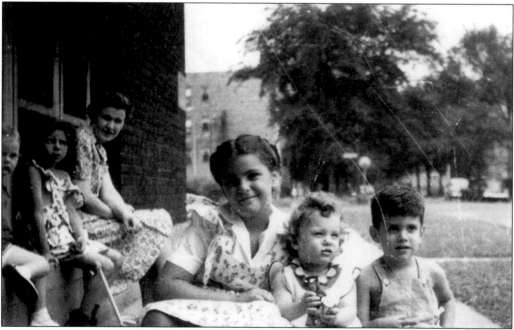

During the late 1930s, Jewish families began moving to West Ridge from nearby Rogers Park and Albany Park. While most Americans were oblivious to the fact, Jews in Europe were already enduring terrifying persecution. "We were quite conscious of being a Jewish family and that there were bad things happening to Jews in Europe," said Nancy Bild Wolf. "But it was still kind of remote to us." (Chuck Stepner collection.)

Imagine the days not long ago when it was common to see a horse in an urban neighborhood. Gas tank looming in the background, this spot is in the far northwest corner of West Ridge at Pratt and Kedzie Avenues near the banks of the North Shore Channel, was the site of a popular horseback riding facility. The horse trail stretched for miles. By the time of this early 1940s photograph, conditions overseas began to demand attention. On December 7, 1941, Japan launched a surprise assault on Pearl Harbor in Hawaii. Though opposed to Japan's imperial designs on China, at the time of the attack, the United States was not at war with any country and had determined to remain out of foreign conflict. Pearl Harbor transformed America overnight, and the next day, December 8, it declared war on Japan. Three days later on December 11, Adolf Hitler declared war on the United States. The days of recreational activities such as horse riding soon came to an end. (RP/WR HS.)

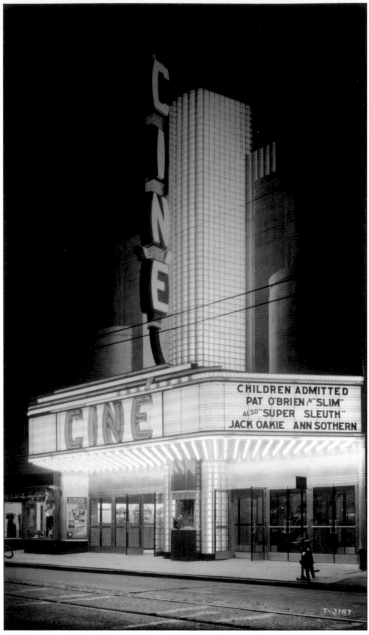

CHILDREN ADMITTED
PAT O'BRIEN IN "SLIM"
ALSO "SUPER SLEUTH"
JACK OAKIE ANN SOTHERN

If there was one business that thrived during the Depression, it was the movies. When folks tell tales of the era, there is always a story about scrounging 15¢ for a trip to the picture show. While the great Nortown Theatre (pictured on the cover) has lingered longer in common memory, West Ridge had not one but two movies houses dating back to the silver screen era. The Cine, designed by Rapp and Rapp, was built in 1937 on Devon and Maplewood Avenues. "The Cine was the cheap theater and featured 'B' movies," said Judge Howard Fink. "I can still remember going to see *Captain Marvel*, the serials and the cartoons there." The Cine lived a relatively short life for a movie house, closing in 1953 merely a decade and a half after its opening. The building survived, though, first as a clothing store and more presently an Indian restaurant. (Courtesy of the Theatre Historical Society of America.)

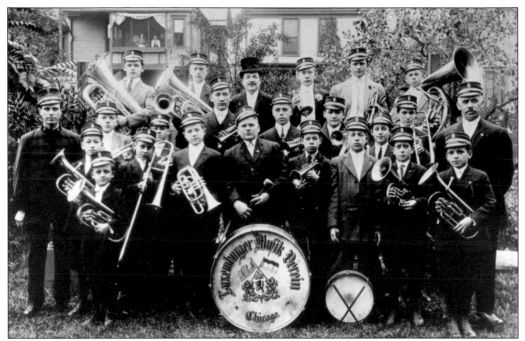

This was the jazz age. Music had always been important to West Ridge from the old-time gatherings at the inns along Ridge Boulevard to the Schmitt family parties with a live band in the parlor and people dancing through the house. In the 1930s, the Germans and Luxembourgers kept their traditional music alive and could kick up a riff that would make even old King Porter stomp. (RP/WR HS.)

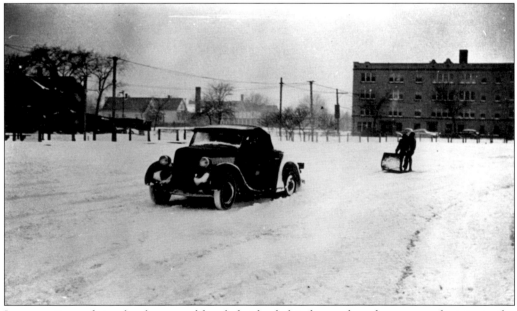

It was a time of simple pleasures, like sled rides behind cars, board games, and visits to the neighborhood park. Indian Boundary Park had opened a small zoo in the mid-1920s and had one black bear. The Tudor Revival field house went up in 1929 and was a great place for puppet shows and other forms of free entertainment. (RP/WR HS.)

This photograph was taken in 1943, one year before D-day. The imperial war machine of Adolf Hitler's Germany, pummeling England, France, and Poland, weighed heavily in the minds of young men in America, most not yet out of high school. Those who were not already fighting in the Pacific knew they were heading overseas to Europe. Just one year later, photographs like this one of a group of leisurely, fresh-faced youths were replaced by those of American boys wearing fatigues, linked arm in arm in training camps, on boats, and across the ocean. The war made a rare sight of boys around West Ridge. But in this image, they remain forever optimistic, untouched by the horrors of battle. (RP/WR HS.)

Here is young Nancy Seyfried with her uncle Charles, a sailor, in the early 1940s. The Seyfrieds, of Lutheran faith, were among West Ridge's German descendents. The Americans that served in the Allied forces included people of every creed and nationality. People of German, English, Japanese, Filipino, and Mexican descent, as well as African Americans, Native Americans, and people of Jewish faith, all joined the fight for freedom. (Nancy Seyfried collection.)

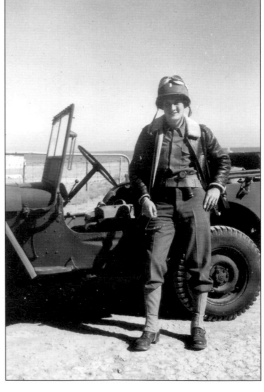

William Holland, pictured in 1944 with the Arizona desert stretching behind him, was one of 550,000 Jewish men and women to serve the United States during World War II. American Jews faced discrimination on a near-constant basis, and persecution of people of Jewish faith in Europe bore a profound effect on the Jewish community. American Jewish casualties from World War II reached 40,000, with 11,000 fatalities. (William and Dorothy Holland collection.)

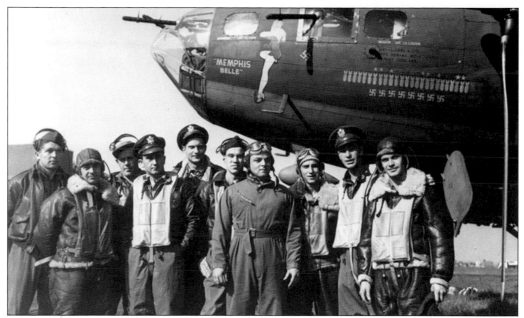

George Petty, who lived in West Ridge through the Depression and World War II, provided young men at war with a new feminine ideal. Petty Girls, voluptuous, long-legged beauties, took the country by storm. No pin-ups, not even those of Betty Grable or Rita Hayworth, were as popular in the barracks as the Petty Girl. Here a Petty Girl decorates the fuselage of a World War II bomber, the *Memphis Belle*. (U.S. Air Force.)

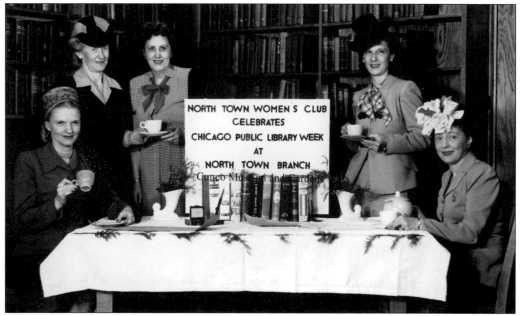

This photograph of the North Town Women's Club shows the tremendous impact World War II had on fashion. In 1942, the War Production Board began severely restricting yardage used in garments. Designers responded by creating a new style—short skirts topped by short jackets. McCall's even produced patterns for transforming men's suits into ladies' suits and women's dresses into children's clothing. (RP/WR HS.)

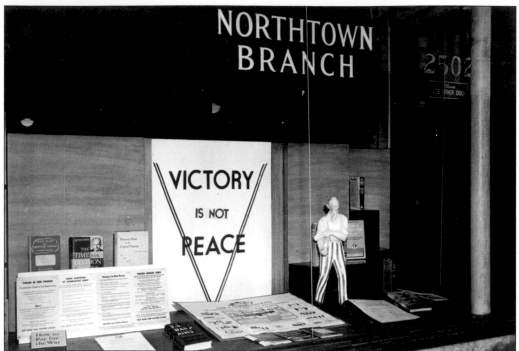

During World War II, everyone got involved. Mothers, grandmothers, great-grandmothers, grandfathers, great-grandfathers, teachers, secretaries, social workers, Boy Scouts, and Girl Scouts jumped full steam into the war effort. World War I veterans and boys too young to join the armed forces served as air-raid wardens, fire wardens, and auxiliary firemen and police in West Ridge. Women worked the blood banks and food banks. Children collected materials vital to the effort, including kitchen grease, aluminum, and cloth. Civil defense (CD) workers in West Ridge held gas defense training at Indian Boundary Park. Boy Scouts, like the ones pictured below, staged massive newspaper drives for the office of civil defense. (Above, RP/WR HS; below, Chicago History Museum, ICHi-22969.)

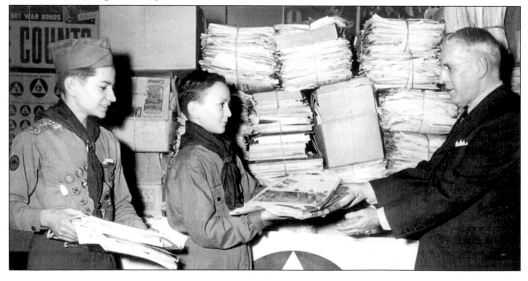

"World War II was the central point in most peoples' lives," said Judge Howard Fink, pictured at right in 1945 with friend Jerry Rosenblum at 2948 West Estes Avenue. "Relatives and neighbors had gone to fight the war, and, at school, war stamps were important." War stamps were so important to Angel Guardian Orphanage (below) that they collected enough to have a U.S. Army jeep dedicated in their honor. "When enough books were filled to average out a book per child, the Army sent one of its new jeeps to Angel Guardian, driven by a WAC and accompanied by a photographer who was an alumnus of Angel Guardian," as noted in *A History of Angel Guardian Orphanage.* "The AGO band provided military music and proudly everyone sang the National Anthem and 'God Bless America.'" (RP/WR HS.)

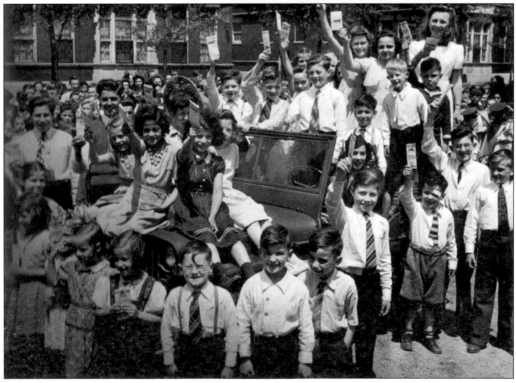

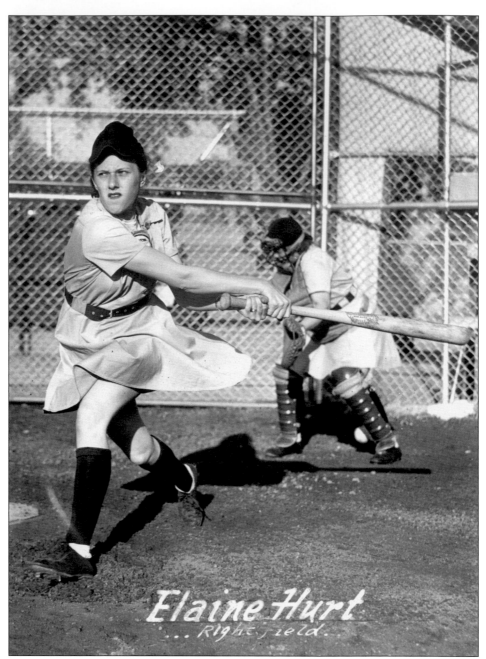

Elaine Hurt
... Right Field.

"Mel Thillens was working as a bank clerk when the Depression hit and the bank closed. He then went to work at a currency exchange and shortly thereafter thwarted five bandits," as recorded in the *Historian*. "After this episode, the owner sold the business to Mel." Imagine for a moment an America where it was rare to see a young, able-bodied man anywhere, working behind the counter or in a factory, playing high school or collegiate sports, in class. Now further imagine this dearth of men reaching the world of professional sports. When Mel Thillens built the North Town Currency Stadium (later Thillens Stadium) in 1938, he created a neighborhood icon, a ballpark on the edge of West Ridge. During World War II, answering the call to keep professional baseball going, he helped create a legend. (RP/WR HS.)

Major League Baseball faced a shutdown, as there were not enough men stateside to keep the league going. A group of Chicago businessmen led by Cubs owner Philip K. Wrigley, and including West Ridge titan Mel Thillens, acted swiftly to keep the national pastime alive with sex appeal, by organizing the All-American Girls Professional Baseball League (AAGPBL). Young women came from all over America to try out at Wrigley Field, and players were chosen based on their athletic ability and attractiveness to the eye. Thillens hosted AAGPBL games through the life of the league, from 1943 to 1954. Here is Mel Thillens at Thillens Stadium with two athletes in heels, customary for photo ops of the day, with the ever-present West Ridge Gas Tank in the background. (RP/WR HS.)

When West Ridge native Martin J. (Marty) Schmidt joined the army to serve in World War II, he took his natural talents as a photographer to the front lines as a member of the Army Pictorial Service Signal Corps. While in England he experienced Adolf Hitler's overhead bombardment first hand. Schmidt captured this never-before-published shot of the prime minister of Great Britain, Winston Churchill. (Courtesy of Martin J. Schmidt.)

With World War II coming to a close, the face of America was transforming. But the influences lasted, including the pulled-back hairstyle of American women. During wartime, women who worked in munitions factories needed a style that kept the hair off the shoulders and back from the face to prevent catching in the machinery. Enter the practical, teased updo, still worn by grandmothers across the nation. (Chicago History Museum, ICHi-25611.)

Seven

WAR, PEACE, AND WAR

Every ethnic minority, in seeking its own freedom, helped strengthen
the fabric of liberty in American life.

—John F. Kennedy (1917–1963)

Through the Depression and the war years, the greatest generation toiled, struggled, fought, died, and kept the movies and baseball alive. Hundreds of thousands of soldiers returned stateside, reuniting with families, starting new ones, helping the wounded heal, and mourning the dead. Veterans struggled, often in silence, with wartime traumas. Americans were keen to put the war behind them. It was time for a quieter life, the beginning of the idyllic family.

West Ridge, with its tree-lined streets and small bungalows, fit the bill. Veterans, returning from the war with government housing benefits, sought space in the neighborhood. Many took shelter in prefabricated temporary housing on the grounds of Philip Rogers Elementary School while they waited for new houses to be built. The nation's housing shortage touched every city and every town, and in West Ridge, developers came in on a fast track. Within a few years, all of the available land was filled in with an "instant neighborhood." Across the country, the population grew by 36 percent between 1940 and 1960, but home ownership grew much faster—by 92 percent. Nowhere in the city of Chicago was that trend more evident.

In postwar Chicago, Jews still faced widespread anti-Semitism. West Ridge, with a growing Jewish presence since the 1930s, was one of only a few city neighborhoods where Jews felt at home. Those looking to leave the older communities on Chicago's west side started moving into higher-status West Ridge in large numbers. As the new houses flew up like wildflowers in the prairie, they were promptly filled with new residents in search of the American dream.

In West Ridge, as throughout the country, the baby boom was in full swing and the 1950s certainly became the decade of the child. Postwar children in their jeans and loafers roamed the neighborhood, congregating at the neighborhood parks and delis. The cultural consciousness of the community was evolving.

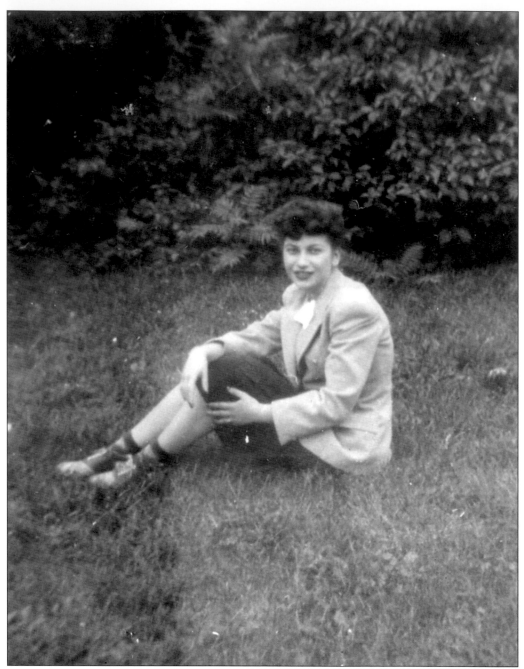

Here is Dorothy Holland as a young bride in the late 1940s. After the war, she and her husband, William, built their brand-new home on Pratt Boulevard near the corner of California Avenue with the aid of the GI Bill. "I remember when there were no sidewalks on the west side of California," she said. The Hollands were among a generation of Jewish couples to settle in postwar West Ridge, early enough that the land visible from their western windows was still wild, open prairie. "I used to kick wild pheasant out of my way as I went out the front door in the morning," said William. The Hollands have lived in the same house for nearly 60 years. (William and Dorothy Holland collection.)

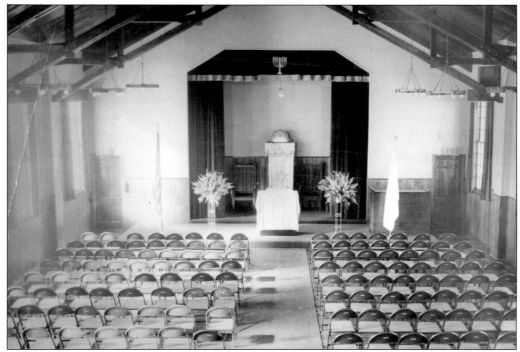

To meet the needs of a growing Jewish population, synagogues began to spring up throughout West Ridge. The reform congregation North Boundary Temple, under the leadership of Rabbi Joseph Strauss, came about in 1946, meeting first at a hall at 6424 North Western Avenue. Shortly thereafter, the congregation changed its name to Temple Menorah and broke ground for a new building (pictured) at Sherwin and California Avenues. Congregation KINS established its own presence at California and North Shore Avenues in 1949, and throughout the period, new Jewish congregations made their homes in West Ridge. (Chuck Stepner collection.)

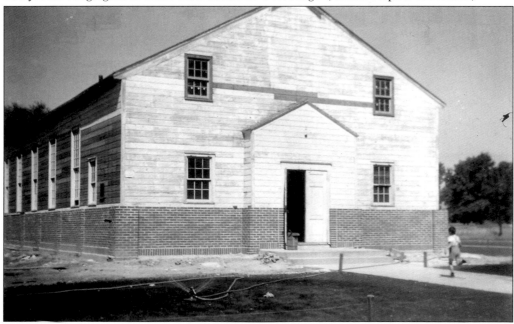

It was possible to make a decent living within walking distance from home. William Holland supported his young family working at Bell and Howell, which was about a 20-minute walk west from his home at Pratt Boulevard and California Avenue across the North Shore Channel on the edge of Lincolnwood and Chicago. Here, Bell and Howell employees enjoy the convenience of Mel Thillens's mobile check-cashing service on payday. (RP/WR HS.)

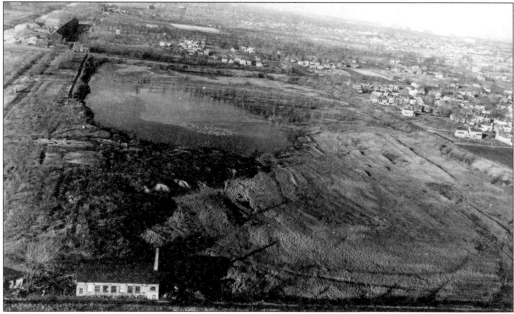

On Holland's way to work, he may have passed the clay pit. Once an active mining site, by the late 1940s the abandoned pit had transformed into a rich wildlife refuge and became an often sought bird-watching site. "Red-winged blackbirds nested in the cattails and rails, coots and gallinules in the marshy edges," wrote Janet Zimmerman of the *Chicago Sun-Times* in 1961. (Chicago History Museum, ICHi 32280, photograph by Edward J. Taylor.)

The days of the clay pit as an ecosystem were not to last. Since the mid-1940s, officials had marked it as a waste dump. "The possibility that the huge West Rogers Park clay pit might be used as a dump without opposition by surrounding property owners appeared this week following a conference between the West Rogers Park Property Owners association and the president of the Illinois Brick Company, which owns the pit," wrote the *Rogers Park News*, 1944. Through the end of the 1940s environmental groups made efforts to save the pit. "We had complete plans for developing the park—a high wire fence around the base of the pit to protect children; lawns and benches where people could sit and look out across it and watch the birds," wrote Zimmerman. But on the flip side, many residents considered the pit an eyesore and demanded that it be filled. There was also a pervasive fear that children would get hurt playing in or near the pit, and that it was a breeding ground for vermin. (Chicago History Museum, ICHi 32280.)

Devon Avenue had already been established as the area's prime business district with a major shopping area and the Nortown Theatre at the corner of Devon and Western Avenues. This golden area for real estate was a prime location for the opening of the Devon-North Town State Bank. The bank's founders were local merchants who believed the developing neighborhood would benefit most with a community bank supporting it. (RP/WR HS.)

With the growing baby-boomer generation and more and more families moving in, houses popped up like dandelions. Where the financing is needed, the money shall follow. To compete for the business of rapid ensuing development in the neighborhood, the new Cook County Federal Savings Bank opened nearly across the street from Devon-North Town State Bank in 1948 in this tiny corner storefront at 2326 West Devon Avenue. (RP/WR HS.)

In the late 1940s, West Ridge had many distinct faces, including the mature residential area along Ridge Boulevard, the Northtown business district of Devon and Western Avenues, and the acres and acres of empty lots west of California Avenue. Here, young Chuck Stepner (far left) hangs out with his friends in one of those lots in 1949. The sign behind them, reading "Burgherd & Sons," more commonly known as the "egg factory," is the backside of a building on California Avenue. The wide-open spaces surrounding them soon disappeared as the residential area took shape, and the second half of the 20th century filled their blocks with new buildings. To these kids and their entire generation, the name West Ridge was a peculiarity. "It's always been West Rogers Park," said Stepner. "We never knew it as anything else." (Chuck Stepner collection.)

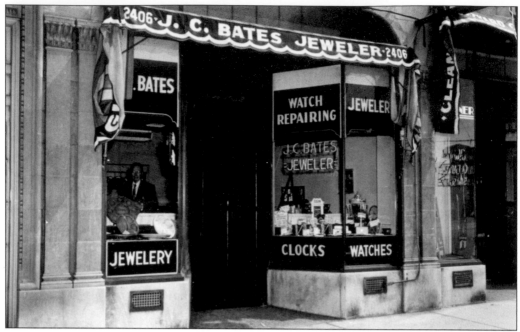

Though Devon Avenue was indeed the main business district, it certainly was not the only one in the neighborhood. A full 12 blocks north on Howard Street and Western Avenue, another, different kind of business model was taking root—the shopping center. Though the concept of the strip mall was around since the 1920s, it did not really catch on until after World War II. But when it did take hold, it changed the face of shopping. Pictured above is the J. C. Bates Jeweler in its original storefront location in the late 1940s. In the 1950s, Bates moved his shop to the new Howard-Western Shopping Center on the border of West Ridge and Evanston. The shopping center introduced a convenience necessary to the modern housewife, namely a parking lot, and several stores in one area. (RP/WR HS.)

303 BOONE SCHOOL 4A-5B. SEPT 1949.

In the ensuing decade, West Ridge led the city of Chicago in the most dramatic residential construction boom of the day. In 1956 alone, the neighborhood recorded 633 new housing units, while Rogers Park followed at a distant second with 233 new units. The following year, West Ridge beat its own record with the construction of 802 new homes, again besting all other areas in Chicago for construction. The country's ongoing population explosion plus the massive influx of new families to West Ridge meant that the once modestly populated neighborhood now faced a serious school-overcrowding crisis. There simply was not enough room for all the students. To address the situation, the school board instituted shift schooling, where half the school attended classes in the morning and the other half in the afternoon. But that proved only to be a temporary solution as more and more students came of age. Pictured here is a 1949 class at Daniel Boone Elementary School. By the early 1950s, Boone added eight more classrooms. (RP/WR HS.)

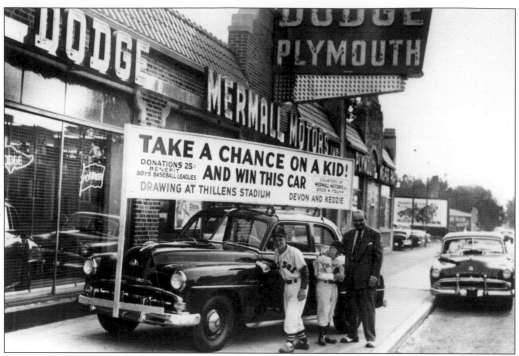

After suffering the hardships of the war years, Americans welcomed the chance to have fun. Little League baseball was a natural extension to this ideal—children should enjoy the national pastime. Nobody was more supportive of boys' baseball than entrepreneurial titan Mel Thillens, owner of Thillens Stadium on Kedzie and Devon Avenues. However, while Thillens's ball field is so often associated with West Ridge lore, it is actually located in Lincolnwood. Above, two young baseball players pose with Thillens at the local Dodge dealership. Many more dealerships sprouted up in the ensuing years, especially along the heavily trafficked Western Avenue near Peterson Avenue, known in the neighborhood as "auto alley." (RP/WR HS.)

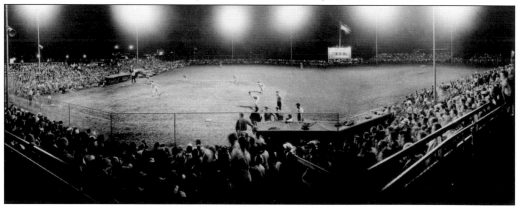

Television shows from the 1950s seemed preordained to preserve the idyllic America, where a kid named Beave learns the value of a dollar and says things like, "Gee, Mom." Pictured here are Nancy Seyfried and her younger brother Bob, playing in the getup of the day, cowboy garb made popular by movies and television shows like *Daniel Boone*, who, incidentally, is the namesake of West Ridge's Boone Elementary School. (Nancy Seyfried collection.)

Even the idealistic parents of the 1950s could not raise their kids in a trouble-free world. Chuck Stepner (pictured) recalls passing the decade under threat of nuclear war and polio, which claimed a number of young people. Television also seemed to have a distancing effect. "I remember the neighbors used to talk to one another over their porches," Stepner said. "But when television came in, people stopped going outside." (Chuck Stepner collection.)

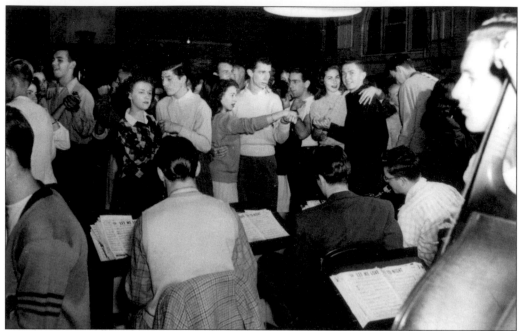

There is no denying it, the 1950s was the era of the teenager. Amid rockabilly, Elvis Presley, Chuck Berry, TV dinners, and sock hops, kids were experiencing youth in all its crazy incarnations. Green Briar Park field house in West Ridge was a hotbed of activity in the 1950s. Below, Mary Jo Behrendt (right) reads *Seventeen* magazine while relaxing in the sun with sister Dorothy Ann in their backyard at 7230 North Ridge Boulevard. Teenagers became viable marketing targets, with publications geared toward selling cosmetics, clothing, candy, and movie tickets—not to mention more magazines—to America's youth. The future Mary Jo Doyle went on to found the Rogers Park/West Ridge Historical Society, but here, like a typical teenager, she is focused squarely on the latest fads and fashions. (Above, Chicago History Museum, ICHi 16962; below, Mary Jo Doyle collection.)

As the population grew, so did the need for a neighborhood high school. The opening of Stephen Tyng Mather High School in 1959 brought some relief to the overcrowding issue, but it did not solve the problem. With classes filled to capacity, some teens still attended public school outside the neighborhood. A unified school identity did not take right away. According to Susan Rosenberg RoAne, "A group of us from Boone and Clinton had a meeting at the North Town Library on California because we knew that we were going to have to give up our school identities and meld together at Mather." It did not take long, however, for Mather and Sullivan (Rogers Park) High Schools to develop a healthy rivalry. (Above, RP/WR HS; below, Chicago History Museum, ICHi 22899.)

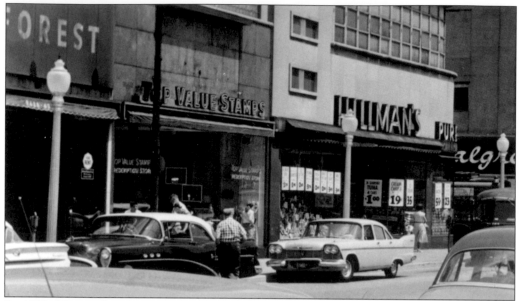

By 1958, West Ridge's Devon-Western district had evolved into one of the premiere shopping districts on Chicago's far north side. The options ran the gamut from the specialty shop to the day's version of the megastore, corner groceries to supermarkets, and boutiques to department stores, including Crawford, Abram's, Kenmac Radio Center, Manzelmann, Woolworth's, Hobbymodel, Ross Barber Shop, and Hillman's subterranean grocery (the infrastructure endures to this day). (Chicago History Museum.)

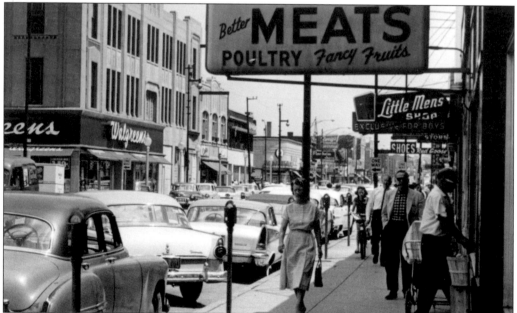

"Next to downtown, Devon was the nicest street in the city," said Ross Felecia. "It was always clean. The stores were very nice and there were some excellent restaurants. People could buy almost everything they needed on Devon." It was, quite literally, the heart of Jewish Chicago. According to Judith Loberg Rock, "Walking on Devon, it was just a Jewish world. Everyone was Jewish, the storeowners, the delis." (Chicago History Museum.)

As the 1950s progressed, the western side of West Ridge began to take shape, and the growing Jewish community was carving a decided identity in the area. When the Stepner family moved onto the 6500 block of North Mozart Avenue in the late 1930s, according to Chuck Stepner, "We were one of the first Jewish families on the block." But as the Jewish presence richened, so did the presence of Jewish establishments. Above, on Devon and California Avenues looking south, notice that the west side is still not fully developed. Below is Nathan's Delicatessen next to F. W. Woolworth in the late 1950s. Jewish delis and bakeries lined Devon Avenue, providing the area's large Jewish population with traditional favorites like corned beef, salami, and pastrami on rye. (Above, Chuck Stepner collection; below, RP/WR HS.)

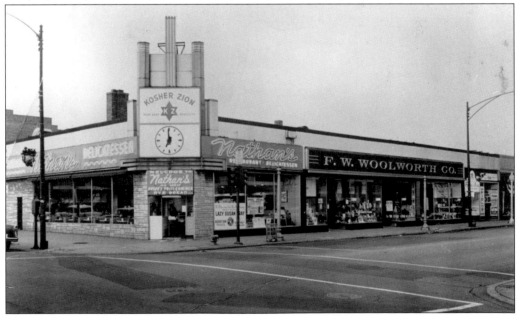

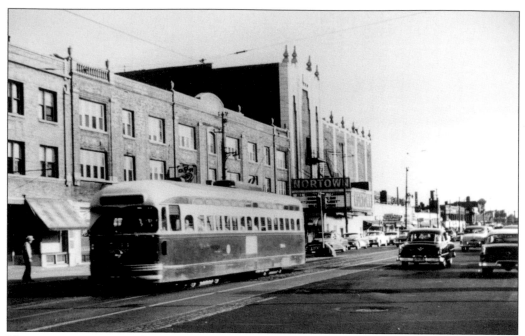

Here, a streetcar passes the Nortown Theater. While perhaps more energy efficient by today's standards, this mode of transit had its drawbacks, namely immobility—if one car stalled, the cars behind could not get around and being tethered to the rail lines made it impossible to veer off course. The rivaling bus system won, and by the early 1950s, all streetcar lines were removed from the area. (RP/WR HS.)

While the Devon-Western area flourished, the outlying portions developed in their own way. To the north, ground broke for the foundation of the High Ridge YMCA (pictured). East of the YMCA was Ed and Erv's Centrella, a family-owned grocery. North on Western Avenue near Howard Street, places like Bill's hotdog stand and the Black Angus served hearty fare. (Chicago History Museum, ICHi-25885; photograph by Martin J. Schmidt.)

Even the area around Devon and California Avenues, which had been slow to develop, was quickly filled in and by 1958 had started to gain the elegance of an established neighborhood in its own right, as exemplified by the new Colonial-style Cook County Federal Savings Bank building, a replica of Philadelphia's Independence Hall. With its preponderance of single-family homes, good shopping, and great restaurants, West Ridge was called "the suburb in the city." Teens sporting the greased-up pompadours of the day hung out at Randl's Restaurant on the southwest corner of California and Devon Avenues, while families dined directly across the street at Kofield's, a bright comfortable restaurant-diner. Just down the street was a first generation walk-up McDonald's that touted a "take-home" meal that could be enjoyed at home in front of the television. (Above, RP/WR HS; below, Chicago History Museum, ICHi25859.)

At the beginning of the 1960s, West Ridge's fast-growing Jewish community had established a lasting presence. Jewish Community Centers (JCC) are important resources, addressing social, religious, and athletic needs. JCCs also provide social services for children and help for senior citizens. The Rogers Park JCC, built in 1949, served West Ridge until the 1960 dedication of the Bernard Horwich Jewish Community Center at 3003 West Touhy Avenue (pictured). The Northtown Branch of the Chicago Public Library also responded to the demographics of the neighborhood, sponsoring special events like Jewish Book Month. By the end of the decade, the number of Jewish residents in West Ridge surpassed any other Chicago neighborhood, making it the city's premiere Jewish community. (RP/WR HS.)

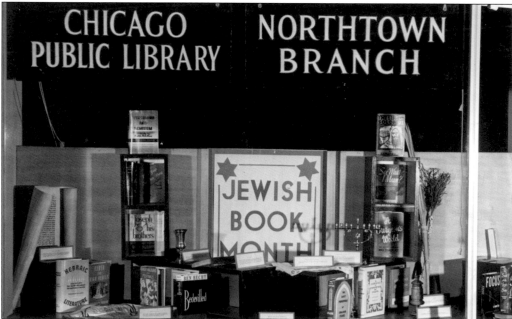

The 1960s was an interesting time to be a teenager. It was an unparalleled era for social change on so many fronts, including civil rights, women's liberation, and the sexual revolution. The decade happened because of the efforts of America's young people to cause radical shifts in thinking. It was a time of extreme transitions, from the conservative age of their parents to the freewheeling hippie culture. But real dangers weighed heavily on young minds. The 1960s saw the assassination of Pres. John F. Kennedy, Rev. Dr. Martin Luther King Jr., Malcolm X, and Medgar Evers. In the north and south, students—black and white—were fighting racism, and the black power movement was on the rise. Jim Morrison and Janis Joplin were bringing a new sound to the ears. And on the horizon was a war with a country in Southeast Asia that before then most Americans had never heard of—Vietnam. America's well-protected baby boom generation was well on its way to losing its innocence. (RP/WR HS.)

By the 1960s, West Ridge had grown into an older neighborhood with an established Jewish presence. But as the buildings began to mature and the business district showed signs of age, the Jewish community began expanding westward to Skokie and into the well-to-do north suburbs. Once again, new immigrants set sights on this area. From as far away as the warm waters of the

Mediterranean to South Asia experiencing its own revolutions and meteoric changes, Chicago's far north side represented an unbeatable appeal—affordable housing, a safe place to create a home, a welcoming environment for entrepreneurs and small business owners, and good schools and parks. (RP/WR HS, photograph by Martin J. Schmidt.)

Although they had carved out a tight-knit community that was fairly self-contained, West Ridge residents were not immune to the larger world—the struggle for equality, the fight for environmental protections, and the war in Vietnam. Here is 1st Lt. David A. Fortman, with the U.S. Air Force Special Forces in Nha Trang, Vietnam. Fortman, a member of one of the neighborhood's founding families from the ridge, flew more than 100 night-protection missions during his tour of duty. He lives today in a house on North Ridge Boulevard built by his ancestors Peter and Elizabeth Schmitt in 1871. His family crossed an ocean, cultivated a land, built a community, and worked hard to become strong, proud Americans. Like young Fortman in this photograph, his family's legacy stands unwavering in the face of the approaching future. (David A. Fortman collection.)

Eight

REBIRTH

Remember, remember always, that all of us . . . are descended from immigrants and revolutionists.

—Franklin D. Roosevelt (1882–1945)

During the 1970s and 1980s, many in the high-income postwar generation packed their bags, sold their properties, and headed to the suburbs. The once-grand Devon Avenue, with its elegant clothing stores, discount toy shops, and department stores, began to fade. Neighborhood homes began to age.

Their departure left room for new immigrants who filled the empty apartments and established their own shopping districts on Devon Avenue. In the early 1970s, the Greeks and Assyrians claimed space in West Ridge. But in 1974 with the opening of the first Indian store, the stage was set for a flood of new immigrants from South Asia. By the 1980s, Indians were buying leases on Devon Avenue in large numbers, and before long, Devon Avenue hummed anew. Pakistanis and Bangladeshis followed, and the mile-long stretch from Ridge Boulevard to California Avenue acquired a distinctly South Asian identity, with ethnic, family-owned establishments becoming the new anchor of this shopping district.

West of California Avenue was also transforming. Jewish organizations and institutions established during the postwar generation began attracting a younger Orthodox generation. The result is a very visible and vibrant Jewish community—groups of full-bearded men in long dark coats and wide-brimmed black hats on their way to synagogue, young Orthodox women in long skirts and knee socks visiting kosher merchants along Devon Avenue, and whole families walking together. In parks and schoolyards, boys play catch wearing yarmulkes and their hair in payos, which hang in curls along their face.

West Ridge in the 21st century stands as one of Chicago's most diverse communities, extending beyond race and ethnicity to include a swath of economic classes and religious groups. Some refer to West Ridge as a miniature United Nations, and Devon Avenue is dubbed "the International Marketplace." Others point out that in West Ridge there are several distinct neighborhoods, each with its own cultural identity.

Today West Ridge is at a crossroads. In the coming years, it is unknown if the social, political, and religious institutions will encourage narrow, ethnic identification and pull people in opposing directions or if there will be enough common interests to keep this community strong.

Since its inception, West Ridge has been a port of entry for many new immigrant groups. Devon Avenue, teeming with restaurants, stores, and flower shops, has been the neighborhood's commercial hub. Originally named Cart Road, the street was renamed Devon in the 1850s after a similarly named street in Philadelphia. It first developed in the years following World War I, so many of the buildings are modest, early 1920s brick buildings, although there are some late-1920s terra-cotta designs as well as some early 1930s art deco–influenced looks. Always busy, Devon Avenue has seen the rise and fall of numerous businesses throughout the years. Unlike this scene from the 1970s where English signs abound, today's Devon Avenue is lined with signs in Hebrew, Arabic, Urdu, and Gujarati. The street has become an international marketplace that highlights the great diversity of Chicago and attracts thousands of visitors each year. People from all corners of the earth have heard about Devon Avenue. (RP/WR HS Lerner Newspapers Collection.)

In the mid-1970s, the demographics of the neighborhood began to change. New immigrants were arriving in large numbers, seeking refuge in the tree-lined streets of West Ridge. Iraqi-born Assyrians arrived in the mid-1970s as refugees of the Lebanese Civil War. Many more Middle Easterners arrived during the 1980s and 1990s, after being driven from their homes by international forces such as the Iran-Iraq War, conflict in Afghanistan, and the Gulf War of 1991. (RP/WR HS Lerner Newspapers Collection.)

India Sari Palace, the district's first Indian store, opened its doors in 1973 at 2538 West Devon Avenue. The growth of Devon Avenue as a major South Asian shopping center lined with Indian and Pakistani restaurants, grocery stores, boutiques, and jewelry shops occurred during the 1980s and 1990s as a result of new immigration from South Asia. Today this section of Devon Avenue is known commonly as "Little India." (RP/WR HS Lerner Newspapers Collection.)

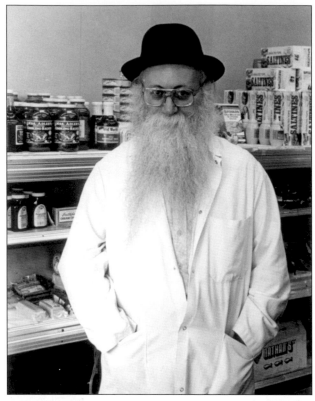

Here is Meyer Raphael Miller. While the 1970s saw a decrease of many Jewish businesses along Devon Avenue, there were some butcher shops, bakeries, and delis, like Jacob Miller and Sons Butcher Shop at 2725 West Devon Avenue, which endured. These businesses, combined with the many synagogues that lined California Avenue and the strong Jewish presence in the community, attracted new Jewish immigrants, including many young Orthodox from the former Soviet Union. Today West Ridge is still home to the largest concentration of Jews in the city of Chicago (Sulzer Regional Library, Historical Room, Chicago Public Library.)

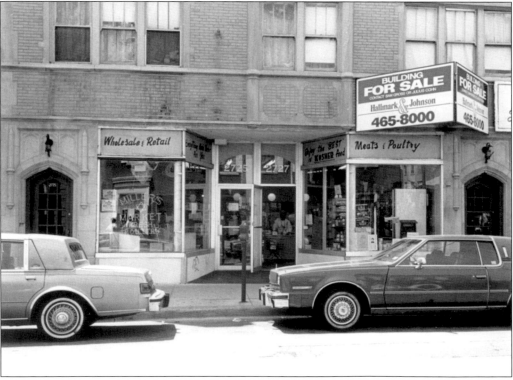

Nowhere in the city is there greater access to all things Jewish than in West Ridge. There are more than 20 congregations in the area, the majority of which are Orthodox or traditional. There are kosher butchers, bakers, restaurants and food markets, Jewish high schools, community centers, convalescent homes, and other Jewish organizations. (RP/WR HS Lerner Newspapers Collection.)

The growth of the Orthodox Jewish community in Chicago's West Ridge reflects a desire for family and tradition. Many young people who were brought up in conservative or reform Jewish traditions have turned to Orthodoxy, consciously prioritizing family and community. West Ridge provides a safe and nurturing environment in which to carry out their lives. (RP/WR HS Lerner Newspapers Collection.)

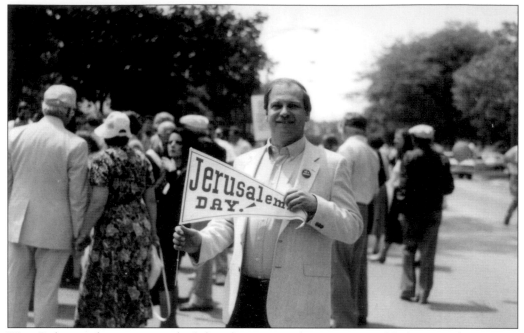

West Ridge residents are proud of their heritage, and on a near-weekly basis in the summer months, festive parades and celebratory processions take to the streets accompanied by flag waving, live music, dancing, and more. Here a neighbor shows off his flag for Jerusalem Day. (Karen Tipp collection.)

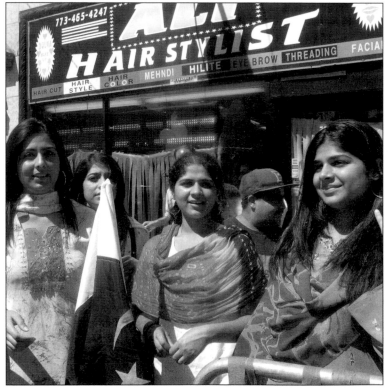

Pakistanis celebrate Pakistan Independence Day each August with an annual parade down Devon Avenue. Even without the parade, the Pakistani presence is visible here, especially between Ridge Boulevard and California Avenue where one will find kabob houses, numerous shops selling Korans, prayer rugs and Arabic alphabet books, and half a dozen mosques calling the faithful to prayer. (Sadruddin Noorani collection.)

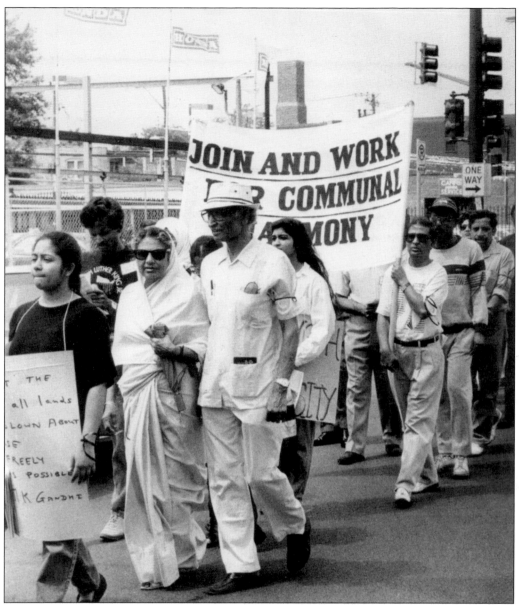

"On Devon Avenue, Pakistanis, Indians and Bangladeshis live, eat and work side by side, though they feel political and ethnic pressures back home," said community leader Sadruddin Noorani. Here, a mixed group of Indians, Bangladeshis, and Pakistanis parade together in celebration of Indian Independence Day. They carry a sign that reads, "Join and work for communal harmony." The man on the extreme right is Dr. Naved Musharraf, brother of the current Pakistani president. In West Ridge, much to the amazement of outsiders, Jews, Muslims, Hindus, and Christians coexist with relative ease in remarkable contrast to the strife and conflict between these groups in the larger world. (RP/WR HS Lerner Newspapers collection.)

Some argue that the relaxed nature of the community is a result of the abundant parkland that past generations worked so hard to obtain. From the formation of the Ridgeville Park District in 1896 to the present day, shared public land has been a top priority for the neighborhood. (Greg Johanson collection.)

Indian Boundary Park, with its petting zoo, duck pond, and picnic spots, is a child's dream come true. The park, which sits on the site of the infamous Indian Boundary Line that once separated those who belonged from those who did not, now serves as a gathering place for all members of the community. (Jamie Wirsbinski Santoro collection.)

Warren Park, the central park of West Ridge, was a hard-won gem born of square-off and controversy. In the 1960s, developers pursued an opportunity to build low-income housing on the then-defunct Edgewater Golf Course, resulting in public outcry and dropping property values. Conversely, community coalitions mounted a campaign to transform the ready-made landscape into public lands. The activists' efforts paid off in 1970, when the state government forcibly intervened on the developers' efforts and acquired some of the property, creating the first Illinois state park within Chicago's city limits. When developers threatened to build on the remaining property, the Chicago Park District stepped in. In 1975, the state of Illinois transferred its portions of the land to Chicago, and the park was named for attorney and activist Laurence C. Warren, a leader in the effort to save the space. (RP/WR HS/Lerner Newspapers Collection.)

While national identity is a prevailing wind of many cultural groups in West Ridge, life revolves around family and this notion creates a unifying vision for the community. Good schools and safe neighborhoods are things that all residents value. Warren Park, Indian Boundary Park, Chippewa Park, and many others provide enclaves where one can get away from it all to escape to fresh air and green grass. (RP/WR HS Lerner Newspapers Collection.)

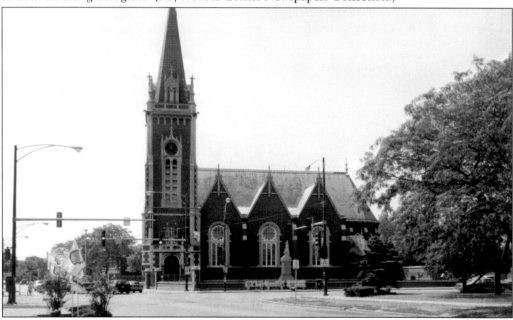

Like the first immigrants who arrived some 150 years ago, the belief that a person can transcend expectations and achieve any goal through integrity, effort, and faith is the very soul of West Ridge. Ask anyone in the neighborhood and they will tell of a neighbor who started with a mere idea and, through enterprise and hard work, transformed it into a small fortune. (Sulzer Regional Library, Historical Room, Chicago Public Library.)

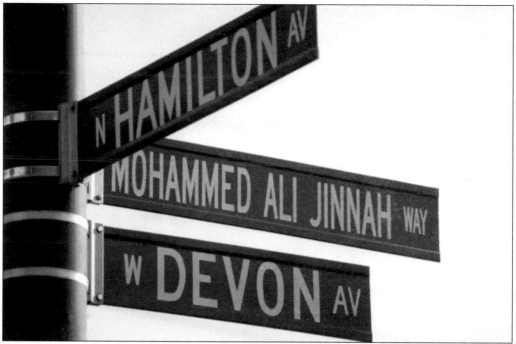

The many honorary street names given to Devon Avenue, including "Sheikh Mujib Way" in honor of Bangladesh's founder and first head of state, "Mohammed Ali Jinnah Way" in honor of Pakistan's founder and first head of state, "Gandhi Marg Avenue" for India's Mahatma Gandhi, and "Golda Meir Boulevard" for the former prime minister of Israel, hint at the ethnic pride found on the sidewalks below. Additionally, Western Avenue, where it crosses Devon Avenue, is named "King Sargon Boulevard" in honor of the great Assyrian king. (Sadruddin Noorani collection.)

West Ridge is a wondrous mix, and despite the separate enclaves, the community coalesces and works together toward common goals. In 1993, over 1,200 community members, many who grew up in the neighborhood, came together to construct the playground at Indian Boundary Park. By working together, West Ridge builds much more than brick and mortar; they build a community for future generations. (Karen Tipp collection.)

The story of West Ridge's transition from a sparsely populated agrarian farming community into a bustling international marketplace is the story of hardship, persistence, and success. Immigrants of all stripes, seeking freedom and economic opportunity and willing to risk a terrible struggle and, in some cases, their very lives, journeyed here and carved out a community along the ridge. Their stories are a record of the human spirit's ability to transcend adversity. Today's residents of West Ridge, like their predecessors in the mid-1800s, have shown that they can work hard, get along, and adapt to American life while celebrating the culture from where they came. West Ridge stands as an example of the American possibility, where residents embrace their own cultures while appreciating others, and they look to the future in an environment of inclusion, collaboration, and pride. (RP/WR HS Lerner Newspapers Collection.)

INDEX

ACROSS AMERICA, PEOPLE ARE DISCOVERING SOMETHING WONDERFUL. THEIR HERITAGE.

Arcadia Publishing is the leading local history publisher in the United States. With more than 3,000 titles in print and hundreds of new titles released every year, Arcadia has extensive specialized experience chronicling the history of communities and celebrating America's hidden stories, bringing to life the people, places, and events from the past. To discover the history of other communities across the nation, please visit:

www.arcadiapublishing.com

Customized search tools allow you to find regional history books about the town where you grew up, the cities where your friends and family live, the town where your parents met, or even that retirement spot you've been dreaming about.